THE AMERICAN AUTOMOBILE

Advertising from the Antique and Classic Eras • Yasutoshi Ikuta

Chronicle Books • San Francisco

First published in the United States 1988 by Chronicle Books

English translation copyright © 1988 by Chronicle Books

*American Car Graffiti 1902—1930: Selections from Yasutoshi
Ikuta's Collection of Automobile Advertisement* copyright © 1986 by
Jitsugyo No Nihonsha, Ltd. First published in Japan 1986.
Edited and compiled by Yasutoshi Ikuta.

Printed in Japan by Dai Nippon Printing Co., Tokyo.

Library of Congress Cataloging in Publication Data

The American automobile.

Translation of: American car graffiti.
1. Advertising—Automobiles—United States—Pictorial works. I. Ikuta, Yasutoshi.
HF6161.A9A4413 1988 659.1'9629222'0973 87-25017
ISBN 0-87701-451-5 (pbk)
ISBN 0-87701-522-8 (cloth)

Translation: Barbarine Rich
Editing: Terry Ryan
Composition: On Line Typography
Cover design: Karen Pike

Distributed in Canada by
Raincoast Books
112 East Third Avenue
Vancouver, B.C.
V5T 1C8

10 9 8 7 6 5 4 3 2 1

Chronicle Books
San Francisco, California

CONTENTS

PREFACE

The 120 advertisements in this book span a thirty-four-year period in American automobile history, with a two-year interruption (in 1917 and 1918) during World War I when few cars were produced for personal use. The magazines in which these ads appeared from 1902 through 1936 include: *Life*, *House and Garden*, and *Vanity Fair*—all leading illustrated publications of the day.

This unique collection begins in 1902 during the early period of motorization when the "new" means of transportation, devised in Europe to replace the horse-drawn carriage, was being put to practical use in America. Henry Ford introduced his Model T in 1908, and by 1925, car owners in the United States numbered over twenty million. Just four years later in 1929, American car manufacturers sold a record 4,460,000 automobiles. Sales in these first decades increased so greatly that by the start of the Depression, the country was fast earning its reputation as a "nation on wheels."

The ads are presented in chronological order to give the reader a visual grasp of the development and changes made not only in car production, but in the lifestyles of the people who purchased those cars. A more academic book using the same ads might be appropriately titled "The Development of the American Automobile and the Changes in American Lifestyle as Seen Through Car Advertisements."

The color illustrations skillfully convey the flavor of the times and strongly reflect the then-popular art nouveau and art deco design styles, art forms that have always inspired a sense of nostalgia among modern-day Americans.

Even in a country as devoted to nostalgia as the United States is, antiques are not always preserved. Old publications are disappearing at a startling rate. Thus, the pre-World War I magazine ads reproduced here are extremely difficult to come by, even in less-than-mint condition. The antique cars shown in these pages have become unfamiliar objects to most people.

The fifty or so different car models in the ads shown in this collection represent nearly the entire spectrum of antique and classic American cars. Each of these models has features and a craftsmanship not found in the cars of today, which, in comparison, seem like plastic boxes containing mechanical parts.

Needless to say, the world of advertising does not always represent truth or reality. Yet the make-believe world created by these old car ads shows the pride Americans have had for their automobiles throughout the years. They were buying, after all, an American Dream.

A Short History of the Motorization of America

• In 1902, *Life* magazine published the first automobile advertisement.

Although more than fifty companies were producing and selling "carriages without horses" at the end of the nineteenth century, none of these fifty made more than ten cars a month—certainly not enough for the makers to be called automobile manufacturers.

Some true car makers who appeared on the scene in the early twentieth century were the Haynes-Apperson Company of Kokomo, Indiana; Olds Motor Works of Lansing, Michigan; and Cadillac Automobile of Detroit. What set these companies apart from their predecessors was their method of operation: they designed the specifications and established clear production plans, which made mass production of the automobile possible. When production had been limited, only the very rich bought cars. With increased productivity, however, the companies could now sell as many cars as they could make—if they could reach and stimulate the interest of the general populace. To promote additional sales, the companies began to advertise.

The first automobile ad published in the United States appeared in the July 3, 1902, issue of *Life* magazine (see *Figure 1*). The Haynes-Apperson ad is simple and direct and shows four passengers riding in a motorized excursion carriage. The second ad published for a car appeared in the November 13, 1902, issue of *Life* and advertised the White Steam Carriage (see *Figure 3*).

With these two ads as forerunners, other car manufacturers followed suit and began to advertise—so much so that by 1903, the magazines hardly had the space to accommodate the rush. Within a few years, the car companies had become the largest advertisers in the country and became more sophisticated in their attempts to reach buyers. By 1909, for example, black-and-white ads were passé, replaced completely by stylish color ads that were imaginative and attractive. From its humble beginnings, automobile advertising had almost erupted into an art form. From this time on, *Life* magazine devoted one page per issue to its "Year 'Round Automobile Show."

• Cars were first powered by steam, then by electricity, and finally by gasoline.

Of the eight thousand cars owned by Americans in 1900, over five thousand were run by steam, a power source that had its benefits and disadvantages. Cars with steam engines had enough power to climb steep grades and the endurance to handle heavy loads, but they were slow, short-lived, and thermally inefficient, and they burned fuel at an astounding rate. Worse, the driver required a mod-

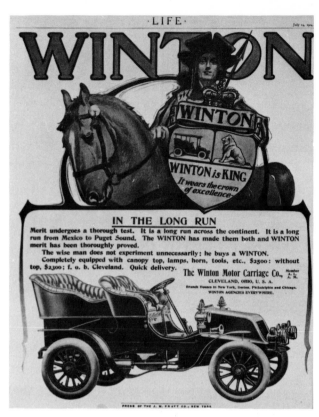

The Winton, which successfully crossed the continental United States in 1897, was used in the movie The Great Race. *(Life, 1904.7.14)*

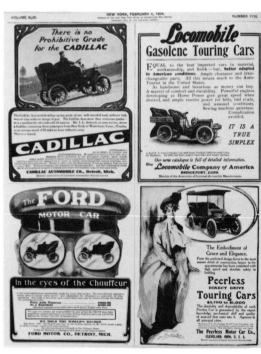

An early car advertisement for Cadillac, Ford, Locomobile, and Peerless. (Life, 1904.2.4)

icum of engineering savvy to maintain the boiler. Despite these drawbacks, however, steam engines powered most cars built before 1903, including the White Steam Carriage (see *Figure 3*) and the Stanley Steamer. With the advent of electrically driven automobiles, steam-driven cars quickly lost their attraction for the car-buying public.

The electric car, a simple vehicle compared to its steam counterpart, was a definite improvement, both personally and ecologically. The drive was smooth and quiet; it did not require a crank to start; better yet, no noxious fumes permeated the atmosphere. Baker Electrics (see *Figures 9, 24* through *26, 40,* and *41*), Waverley (see *Figure 32*), and Rauch & Lang (see *Figure 33*) sold quite a few electric cars because of these features. Unfortunately, however, the electric car was as slow as the steam car and could not travel more than sixty miles on a single overnight charge. Buyers quickly switched their allegiance to gasoline-powered cars when they became available on a large scale.

Of the 212 types of cars exhibited at the All-America Automobile Show held in 1905 at Madison Square Garden, 177 were gasoline-run, 31 were electric, and only 4 had steam engines—a definite sign of what was to come. Gasoline-powered cars could (and can) travel at high speeds, negotiate steep hills, and travel long distances without running out of fuel. Gas tanks could be refilled almost anywhere in the country, and the oil wells being discovered across the state of Texas were incentive enough for car buyers who knew that gasoline would be available and affordable for quite some time.

• The "days of the linen duster."

In the first years of the automobile, you could buy ten horses for the price of the cheapest car on the road. As an example of just how expensive this was at the time, factory workers then made about two dollars a day, and the popular "everyman's car," the two-passenger Oldsmobile Standard Runabout (see photograph on next page), cost $650. The middle-class Winton cost $2,500, and the upper-class Peerless sold for $6,000. Imported cars were even more expensive—the Mercedes, for example, was priced at $7,500. Obviously, most of the cars were owned by the wealthy few, and car companies slanted their advertising to affluent buyers. The drivers and riders in the antique car ads decidedly represent the upper class.

If a car was in your price range at all, the car you probably bought was an open car. Because engine power was not sufficient to carry a heavy box-shaped body, 90 percent of all cars were open (uncovered), which meant that passengers were often blanketed in dust from the unpaved roads. To deal with this onslaught of dirt, women

drivers and passengers donned linen dusters (overcoats) and wide-brimmed hats tied down with scarves, thereby starting a fashion trend that swept the country. In fact, the early age of automobiles is often called the "days of the linen duster."

At about the same time the linen duster became fashionable, the races began. For automobile manufacturers, hill climbs, speed races, and endurance races were ideal opportunities to sell skeptical potential customers on the benefits of owning a car. Races *did* seem to sell cars—after a Packard won a 1903 cross-country race, Packard sold five hundred cars in 1904 to break an all-time record.

Although company-sponsored races were popular, individual owners made racing into a favorite outdoor sport for American city dwellers. In 1909, a group of four women, led by a Miss Ramsey, drove from New York to San Francisco in the then-unbelievable time of fifty-three days, an achievement celebrated all across the country.

The mounting popularity of motor sports was meaningful for the development of the automobile industry but also emphasized the coming need for mass production.

• Mass production and the "Tin Lizzie."

The person who had the greatest influence in making the car available to the masses was the "automobile king," Henry Ford. Following his success in 1896 in designing a two-cylinder, 4-horsepower, gasoline-run car—the Quadricycle—Ford went on to produce ten kinds of trial cars, including the Model A, the Model N, and the Model S. Not until 1908, however, when Ford introduced the Model T, did he begin to make his mark in auto making. In the first year, Ford sold 10,000 of the reliable Model T's at $950 each. Four years later in 1912, sales reached 78,440, a remarkable number for a single car.

In 1913, not yet satisfied with his production levels, Ford borrowed a bit of technology from Chicago meat factories and used conveyor belts to establish his now-famous assembly lines. With prefabricated parts and improved assembly methods, Ford began to produce a thousand cars a day and effectively became a one-man automobile industry. By 1927, fifteen million (68 percent) of the world's cars were Model T Fords.

The Model T (affectionately called the "Tin Lizzie" by its owners) was popular because it was dependable and affordable. Over the years, much to the delight of buyers, the car became even more affordable—as the assembly lines made production costs drop, the retail price of the car also dropped. With prices so low, almost anyone could own a Model T—and almost everyone did.

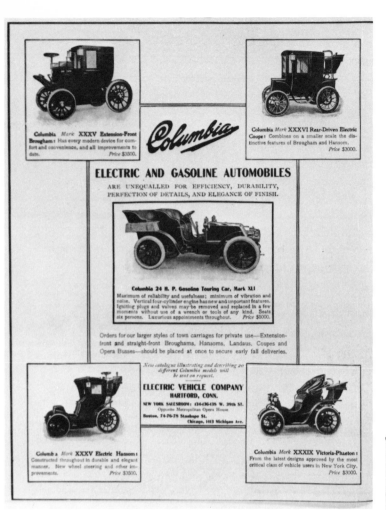

In the early days of the automobile, some manufacturers made and sold both electric and gasoline-powered cars. (Life, 1903.7.2.)

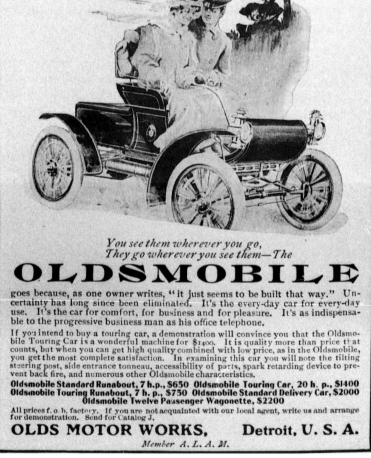

The first mass-produced car in the world—the curved-dash Oldsmobile. (Life, 1905.8.17)

• Americans on the move.

The massive effect of the automobile on American society was quick to occur. The gap (indeed, the very space) that had existed between town and country began to disappear as people gained access to private transportation. The best of both worlds became available to occupants of either, and those who had cars took advantage of the situation. The culture of the city thus spread to the agricultural community; and the peace and earthiness of the country was available to city dwellers.

As a group, women undoubtedly gained the most from this new-found freedom, as the automobile expanded their sphere of activity. They were no longer housebound, and women's suffrage acquired a momentum that might not have existed otherwise.

Furthermore, cars brought pleasure to the people who used them. Going for drives in the countryside or visiting faraway relatives and friends strengthened family and social bonds. Young men and women began to use cars to date, which slowly brought about changes in the sexual and social mores of the nation. Social scientists and anthropologists in abundance have elaborated on the role that the car has played in the sexual liberation of America.

When the popularity of the Model T began to wane, other cars took its place. The $2,129 average price for a car in 1908 dropped to $866 in 1913 and to $603 in 1917. The automobile, by this time, had become an essential "permanent consumer good" in the daily life of Americans.

With the plethora of cars, roads began to be laid out. Along the roads, gasoline stands sprouted up, and around the gasoline stands, stores appeared, gradually creating new towns. This phenomenon occurred in every state throughout the United States. As a magazine of the day stated it, "The world, or at least America, was made for cars."

• "For any purse or any purpose."

In 1917 when the United States entered World War I, the automobile factories stopped producing cars for private use and concentrated on battlefield vehicles and machinery. When the war ended nearly two years later, the country's six million passenger-car owners were ready for a change, and the auto makers obliged them.

American drivers were not as attracted to a *new* car anymore as they were to a *changed* car. A buyer considering a new car had a more extravagant checklist of features, even if the price increased in direct proportion to the number of items on the list. The auto makers began to focus on style, speed, and ease of drive to accommodate consumer demand, and the reasonably priced and practically minded Model T Ford began to lose its sales appeal.

Model T Ford Statistics for the Years 1909–1914

Year	Number Produced	Price
1909	10,607	950
1910	18,664	780
1911	34,528	690
1912	78,440	600
1913	168,000	550
1914	248,000	490

The Number of Cars Owned in the United States

Year	Total Owned	Privately Owned
1895	3,700	3,700
1900	8,000	8,000
1905	79,000	77,000
1910	469,000	458,000
1915	2,491,000	2,332,000
1920	9,239,000	8,132,000
1925	20,069,000	17,481,000
1930	26,750,000	23,035,000
1935	26,546,000	22,569,000
1936	28,507,000	24,183,000

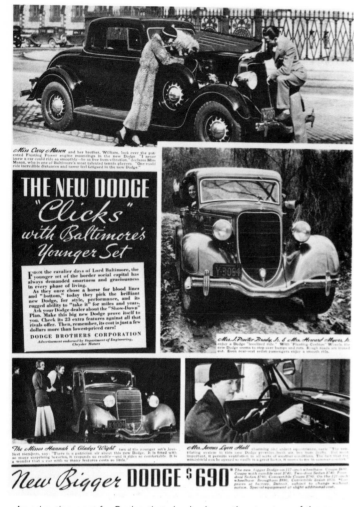

An advertisement for Dodge that clearly shows the structure of the car.
(Vanity Fair, 1934.6)

The first noticeable change made in the car's appearance was the shift from the open-bodied (uncovered) car to the closed-bodied car (or sedan) with an enclosed interior and a full roof. (In 1919, 90 percent of all new cars had open bodies; by 1929, the figure dropped to 10 percent.) Beyond this modification, each car manufacturer had a separate strategy for meeting the new market demands. No company anticipated those demands as well as General Motors (GM), which produced a full series of sedans and later introduced the full-line systems of Chevrolet, Oldsmobile, Oakland (later renamed Pontiac), Buick, La Salle, and Cadillac. In its own words, GM designed cars "for any purse or any purpose." To design its cars, GM brought in Harley Earl, a young car stylist from Los Angeles who, until that time, had designed custom auto bodies for movie stars and wealthy clients. The La Salle, which first appeared on the market in 1927 (see *Figure 112*), was the result of Earl's work.

GM's most successful campaign to increase sales, however, had nothing to do with improvements or styling—it had to do with money. The "drive now, pay later" installment plan introduced by General Motors to help customers buy cars at an affordable pace made the company large and prosperous. GM not only promoted sales, it made great profits from the interest on monthly installments. By 1925, 65 percent of all of the company's cars were sold on the installment plan, and General Motors surpassed Ford in sales to become America's biggest car maker.

• The last hours of the Model T Ford.

General Motors' rise to the top did not come without help from the Ford Motor Company, which had not changed its one and only car—the Model T—in sixteen years. Even the color—black—remained the same, because Henry Ford felt that "a car is a means of transportation. It is no more or less than that." If Ford disliked frills, he disliked the installment method of payment even more. "To go ahead and enjoy oneself without having finished payment is immoral," he said.

Henry Ford could not resist progress entirely, however, and in 1924 put a closed body over the Model T, calling it the "Ford Closed Car" (see *Figures 54* through *57*). Unfortunately, the Model T was designed originally to be an open car, and the engine power was not sufficient to carry the heavy load of the box-shaped body. The Ford Closed Car failed, and the designers went back to their drawing boards.

In 1925, the Ford Motor Company released another ordinary Model T at the unbelievably low price of $260 but could not slow the rapid decline of Model T sales. The

times demanded cars of a type totally different from the low-cost, efficient Model T, and Henry Ford finally decided to stop production of his legendary car.

On May 31, 1927, Henry Ford's personal choice in transportation went off the assembly line. In the end, the figures were dazzling. In all, 15,007,033 Model T's were produced since 1908, and with the last car, the first golden age of American automobiles came to a close.

• Surviving the Depression.

By 1925, over twenty million people, representing two-thirds of American households, owned private cars. The United States became known as a "nation on wheels," reflecting the prosperity of its citizens and its industry. During his term, President Hoover lauded the success of American capitalism, and Americans dreamed of two cars for every garage. The automobile industry was drunk with success.

Until the twenties, the prime considerations in making (and buying) cars had been practicality and economy, and early advertising copy emphasized durability and reliability. When the car makers later realized that customers wanted and could afford a touch of elegance in their automobiles, however, the new cars began to show some style, and advertising copy began to stress beauty over the more basic mechanical features (see *Figures 52, 53,* and *61*). In 1929, American drivers bought a record 4,460,000 cars.

Unfortunately, 1929 was a record-breaking year in more ways than one: on October 24 (known as "Black Thursday") of that year, the New York stock market collapsed, starting a worldwide panic that lasted for years. As one magazine of the time wrote, "The roads all around the country are full of cars driven by the unemployed looking for jobs. Farmers in the South are selling spare tires for food, and the unemployed in the middle of the country are loading the roofs of their cars with the barest of belongings and heading to new homes in California. Drives to the outskirts for many people are their only recreation."

Even in the midst of this Great Depression, however, cars were considered a necessity and a recreation. People who skimped on meals bought gasoline. A few people remained wealthy, oblivious to the Depression. In Hollywood, major stars, such as Gary Cooper, Clark Gable, and Greta Garbo, continued to travel around the city in their specially designed, ultra-deluxe cars, drawing sighs from onlookers—and in the movies at least, crime bosses outran the FBI in their Pierce-Arrows, Lincolns, and Packards.

Most Americans of the time, though cognizant of the economic climate, believed that prosperity was, indeed, just around the corner. Enduring daily hardship was made

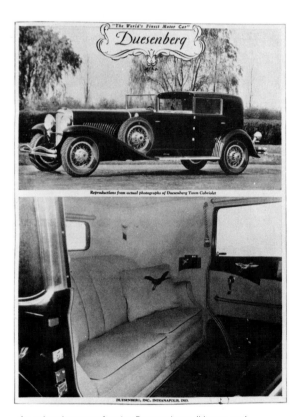

An advertisement for the Duesenberg. (House and Garden, 1930.1)

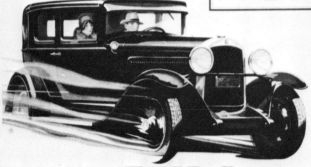

WORLD'S GREATEST SEDAN VALUES !

GREATER BEAUTY ▾ LARGER BODIES

WITH ALL their many improvements, the new Superior Whippet Four and Six Sedans are still notable for their startling low prices. They hold their place as the world's leading values in four-door enclosed cars.

Longer bodies, graceful lines, rich, distinctive colors, higher radiator and hood, sweeping one-piece full-crown fenders and perfection of detail mark the new Superior Whippet as the style authority created by master designers.

As the mechanical triumph of leading engineers, the new Superior Whippet possesses the important advantages of silent timing chain, full force-feed lubrication, aluminum alloy invar-strut pistons, remarkable new "Finger-Tip Control"—and, in the Six, a seven-bearing crankshaft. Long service will prove Whippet's dependability and economy of operation.

"Finger-Tip Control"

—a single button, in center of steering wheel, starts the motor, operates lights and sounds horn.

WILLYS-OVERLAND INC., TOLEDO, OHIO

WHIPPET 4-SEDAN
$595

Four-cylinder Coach $535; Coupe $535; Roadster $485; Touring $475; Cabriolet and Chassis $495.

WHIPPET 6-SEDAN
7-Bearing Crankshaft
$760

Six-cylinder Coach $695; Coupe $695; Coupe (with rumble seat) $725; Sport De Luxe Roadster $850 (including extra tire and extras). All Willys-Overland prices f. o. b. Toledo, Ohio, and specifications subject to change without notice.

NEW SUPERIOR *Whippet* FOURS and SIXES

An advertisement for Willys-Overland. (House and Garden, 1929.4)

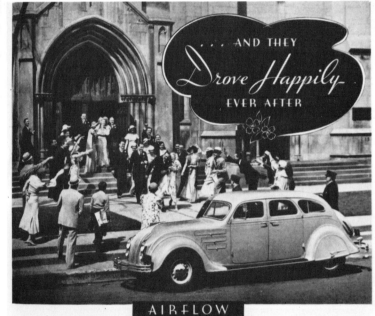

... AND THEY *Drove Happily* EVER AFTER

AIRFLOW CHRYSLER

For the happy bride and groom...the newest and best of everything...the most modern of motor cars...the new Airflow Chrysler!

THERE'S nothing in the whole wide world of motoring that even begins to compare with the luxury of the new Airflow Chryslers.

Their exciting modern beauty... refreshingly different and distinctive. Their superb roominess... great wide doors and seats like divans ... the big inside compartment for luggage. The thrill of speeding along without the pull of vacuum and wind drag. The joy of a ride so smooth you can read or write as you go.

Owning an Airflow Chrysler now gives that rare and special pleasure of anticipating the

inevitable trend of progress ... of enjoying today what everybody will be striving to duplicate tomorrow.

There is a simple way to prove this ... just get into an Airflow Chrysler and let your own sensations be the test!

Write for the interesting free Floating Ride booklet. Chrysler Sales Corporation, 12197 East Jefferson Avenue, Detroit, Michigan.

Four Distinctive 1934 Models

CHRYSLER AIRFLOW EIGHT... 122 horsepower and 123-inch wheelbase. Six-passenger Sedan, Brougham and Town Sedan, five-passenger Coupe. All body types. $1345.

CHRYSLER AIRFLOW IMPERIAL ... 130 horsepower, 128-inch wheelbase. Six-passenger Sedan and Town Sedan, five-passenger Coupe. All body types. $1625.

AIRFLOW CUSTOM IMPERIAL ... 150 horsepower, 146-inch wheelbase. Magnificently sized, individualized body types, priced on request.

1934 CHRYSLER SIX ... With independent spring front wheel suspension, cushioned ride ... 93 horsepower, 7-body types on 117-inch and 121-inch wheelbase. Priced from $775 up. Four-door Sedan, $845. *Prices quoted are prices at which cars of all models at wide $10 accessories. List price of Sedan, Detroit, subject to change without notice.*

An advertisement for the Airflow Chrysler, the first streamlined car in the United States. (Vanity Fair, 1934.6)

that much easier by the dream of being able to purchase a new car someday soon.

• The advent of the large American car.

For the American automobile industry, the Depression was a powerful blow that continued to be felt for years after the crash of the stock market. In the four short years between 1929 and 1932, production declined almost 75 percent—from 5,360,000 in 1929 to 1,370,000 in 1932. Most strongly hit were the makers of cars for the middle class; makers of the more expensive cars remained relatively stable because their buyers remained relatively wealthy.

Every manufacturer attempted to ride out the economic crisis by lowering the prices of high-priced cars to make them available to more people and by developing new models. The new cars introduced during these years had multiple steam cylinders and large-capacity engines—the twelve-cylinder Lincoln (see *Figure 113*), Pierce-Arrow (see *Figure 111*), Packard, air-cooled Franklin, and the sixteen-cylinder Marmon and Cadillac (see *Figures 105* and *120*) are just a few examples. One magazine of the day explained the popularity of these large, powerful cars in this way: "Many people looked at these large, high-class cars hoping in their hearts that one day they would be owners of a car like that. This was the American dream itself. As the years went by, the American car grew even bigger, even wider, even cheaper, and the all-out aim of making truly large-size cars was realized after the Depression ended.

One obvious result of the Depression years was that all car makers changed their cars yearly in an attempt to attract more buyers. Each year, with the approach of autumn, the auto companies announced the new model and created the advertising campaign to stimulate demand. Car ads during the post-Depression years were plentiful and original. Of course, it was not always economically feasible to create an entirely new car each year; in most cases, the "new model" had a slightly adjusted radiator grill or minutely altered headlights. Even such minor changes seemed to satisfy the demand for new products; since that time, American car makers have always thrown out the old to push sales on the new.

• The cars that disappeared.

The companies that managed to survive the first decades of car making and the Depression were few and far between. By 1927, 131 of the 181 companies that had entered into the automobile business since its inception had failed. Following the Depression, the figures were even more severe. From the twenties, in fact, the Ameri-

can automobile industry had come to consist of the Big Three makers—General Motors, Chrysler, and Ford. All other independent car makers combined never realized more than 20 percent of total car sales.

Obviously, the Depression suppressed many individualistic and independent car makers, including the companies that produced the Auburn (see *Figure 115*), the Duesenberg (see *Figures 117* through *119*), the air-cooled Franklin (see *Figures 84* and *85*), the originally advertised Jordan (see *Figures 49* and *58*), the durable Marmon (see *Figures 65* and *94*), the graceful Peerless (see *Figures 15* and *19*), the Pierce-Arrow for educated Americans (see *Figures 2, 5, 6, 7, 14, 28, 29, 30, 81, 83, 92, 97, 99, 109,* and *111*), Cleveland's high-class Stearns (see *Figures 12* and *78*), and America's greatest sports car, the Stutz (see *Figures 50* and *68*). The average life-span of all the car companies established between 1902 and 1926, in fact, was just 9.4 years. Although many people made cars, few of these people seemed to realize their ambitions.

·LIFE·

TYPICAL AMERICAN SLANG.

The following choice bit of slangy eloquence, spontaneous and sincere, is credited by the *Chicago Chronicle* to William Devery, ex-Superintendent of Police of New York City:

"Some time ago," remarked "Big Bill" Devery recently in discussing the election. "I said that David B. Hill was a political holdout man who wouldn't go into the game unless he could feel the marks on the cards through a pair of boxing gloves. He had the cards marked this time, all right, but one night after he had been smoking political dope and was shaking hands with himself in the White House somebody stole the deck from under his liver pad and changed the marks.

"I ain't playing no searchlights on myself as a prophet, but Hill's finish was as plain to me all through this campaign as the Flatiron Building is to a man in front of the Fifth Avenue Hotel. He rung the bell at the front door of the morgue the day he passed me along in the convention at Saratoga. After this his address is 'D. B. Hill, Deadhouse, Compartment No. 13; Handle With Care.'

"Ever since he has been in politics Hill has held a red hand, consisting of four diamonds and a heart. The Democrats have thought all along that in Hill they were holding five diamonds. Sometimes they have carried off a bluff with it and sometimes they have stayed out and let the other fellows chip along, but this year they had to show their four-flush when Odell called them and the Republicans won with a pair of nines.

"It's a funny thing," Mr. Devery went on, "how a human refrigerator like Hill has been able to make people think he was a real live one for so many years. Ever shake hands with Hill? No? Ever go into a market on a cold morning and pick up a fish? Yes? Then you've shaken hands with Hill.

"Up there in Saratoga I stood out on the platform and told Dave Hill that I demanded justice from him. I looked right at him when I said it. Did he look at me? It ain't necessary to give the answer. He looked into Tom Grady's ear like a boy looking into a picture machine. He couldn't look anybody in the face.

"When I said you couldn't elect a bald-headed man President I spoke the truth, but I was talking particularly about a bald-headed man like Hill. Whenever you see a man get bald in front first, so his forehead looks like half of a football, it's a bad sign. And when you scramble that up with a pair of eyes that work like the pendulum on a clock, there's a combination to run around a corner and hide behind a tree from.

"Of course Hill won't stand pat and admit that he lost. He is doing the old stunt—hollering fire from under the bed. When Bryan was 'it' in the Democratic party Hill got into his cage up in Wolfert's Roost, locked the doors on the inside and the only time people knew he was alive was when they heard him snore.

"This year he thought there was a chance to get busy. He gets his 'I am a Democrat' sign out, puts some axle grease on his peanut cart and goes up and down the State telling people that he sets a better table at his house than Ben Odell sets. I don't think anybody believed him at that. He looks like he lived on cracked ice and olives.

"The picture men will have to revise Dave now. They'll have to put crape on his peanut hat and hang a sign on him reading: 'I am a load for a hearse.'"—*Exchange.*

"WHY did you insist on getting me an upper berth in the sleeping-car?" asked a severe and fretful lady of her young companion.

"Well," answered her irrepressible niece, "you have been expecting for so many years to find somebody under your bed that I thought it might relieve your mind to have all doubts on the subject removed for once."—*Washington Star.*

ARCHBISHOP RYAN, visiting a small parish in a mining district for the purpose of administering confirmation, asked one nervous little girl what matrimony was, and she answered that it was "a state of terrible torment which those who enter it are compelled to undergo for a time to prepare them for a brighter and better world."

"No, no," remonstrated the pastor; "that isn't matrimony; that's the definition of purgatory."

"Leave her alone," said the archbishop; "maybe she's right. What do you or I know about it?"—*Argonaut.*

A CAROL OF KINGS.

This is ye seasonne now for Kynges,
Kynge Christmasse and Kynge Coal;
And eache man Christmasse Carols syngs,
And catches gaye and drolle.
Thenne let Us syng, "Long live ye Kynge!
Ye beste Kynge that prevails.
Ye kynge of all ye goode cigars—
El Principe de Gales!"

IT MAY be stated for the comfort of American voters—if married—that an apostrophe of the following size and style costs very little less in England than in the United States:

A frankly unesthetic husband, on his return from a little vacation trip, was led into his London drawing-room, which had been freshly decorated and furnished during his absence by the house of Liberty & Co.

He looked about, as his wife bade him, at the green and purple plush walls and furniture.

"O Liberty, what crimes are committed in thy name!" he murmured, feelingly.—*Youth's Companion.*

SYDNEY SMITH once wittily remarked: "The British army ought never to leave England except in case of actual invasion."—*Argonaut.*

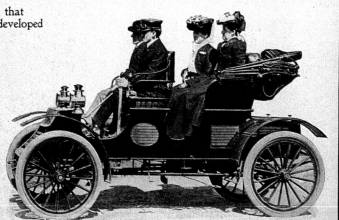

ANTIQUE CARS
1902–1916

Any automobile made before World War I is classified
as an antique car, even though models may vary greatly in design. Some of
the cars are simple "horseless carriages," in which a motor
has replaced the horse; many other models, on the other hand, more closely
resemble modern cars in the positioning of the engine,
gasoline tank, and seats.

•

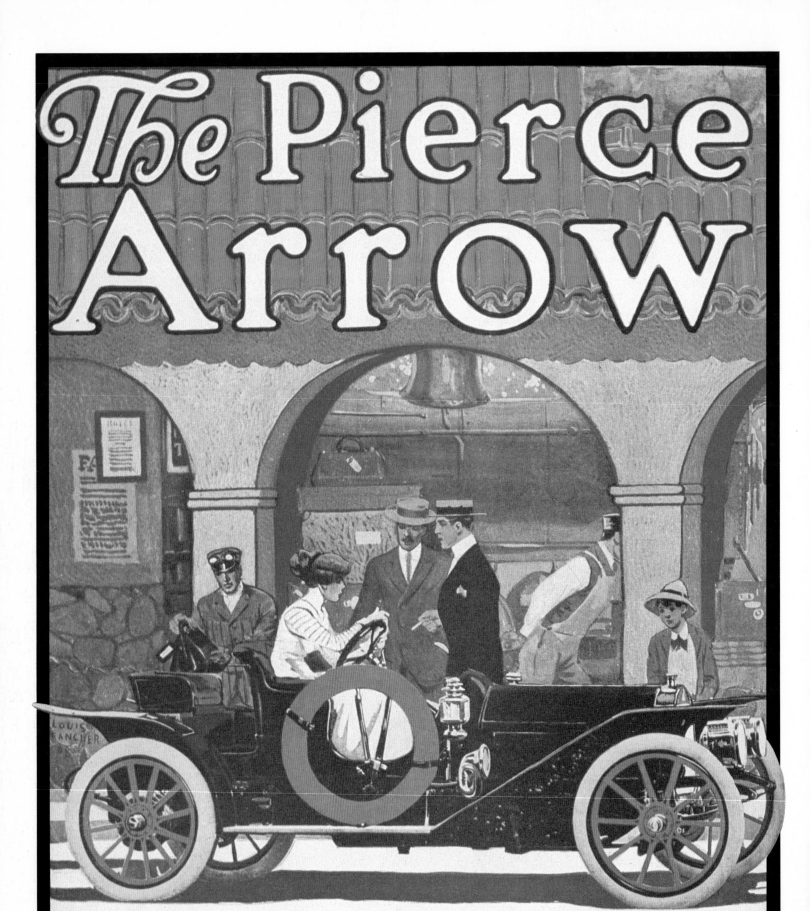

The Pierce Arrow

WITHOUT forgetting that, after all, a motor car is a piece of machinery, the Pierce Arrow has never failed to offer its owner the highest luxury also. Here is the Pierce Runabout, the same effective Pierce chassis, fitted with a smaller body, combining all of the efficiency of the Pierce engine with the convenience of a runabout.

Two Passenger Runabout, 24 H. P. $3,050 36 H. P. $3,700 Three Passenger Runabout, 24 H. P. $3,100 36 H. P. $3,750

Pierce Arrow Cars will be exhibited in New York only at the Madison Square Garden Show, January 16 to 23, 1909, and at the salesroom of our New York representatives, The Harrolds Motor Car Co., 233 W. 54th St.

THE GEORGE N. PIERCE COMPANY (Members Association Licensed Automobile Manufacturers) BUFFALO, N. Y.

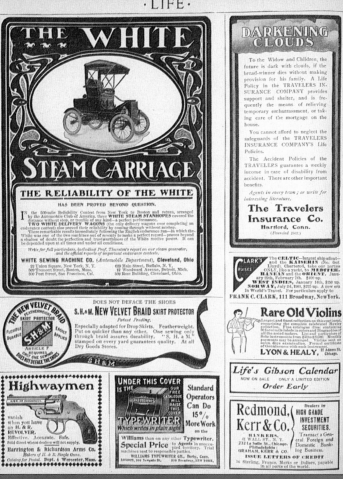

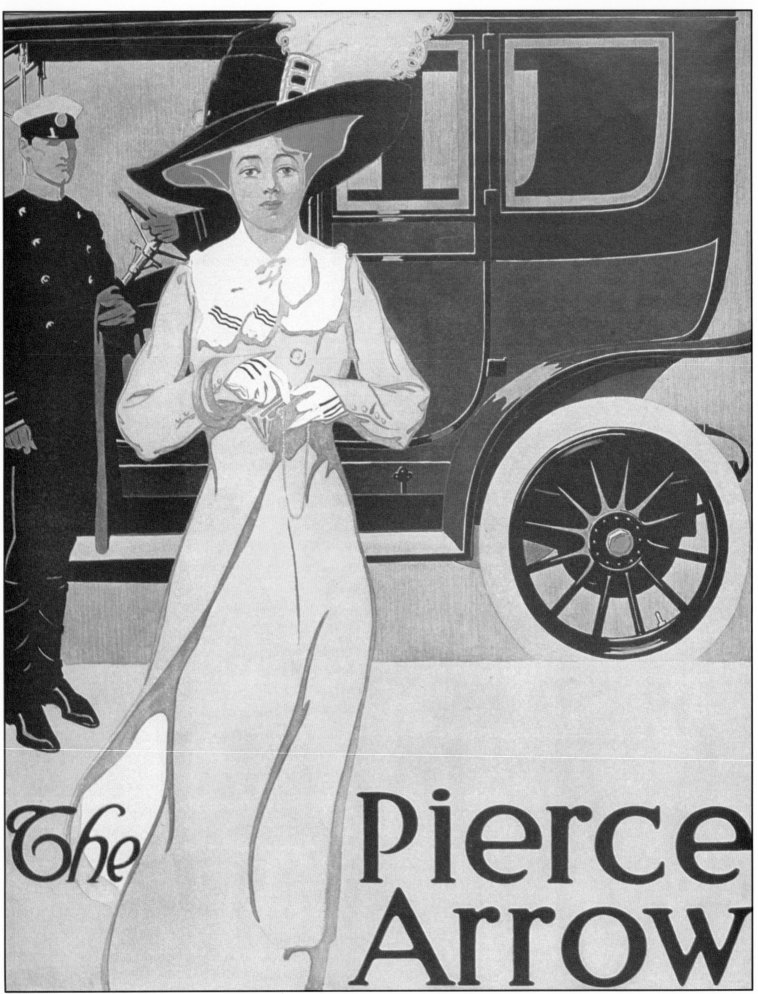

The Pierce Arrow

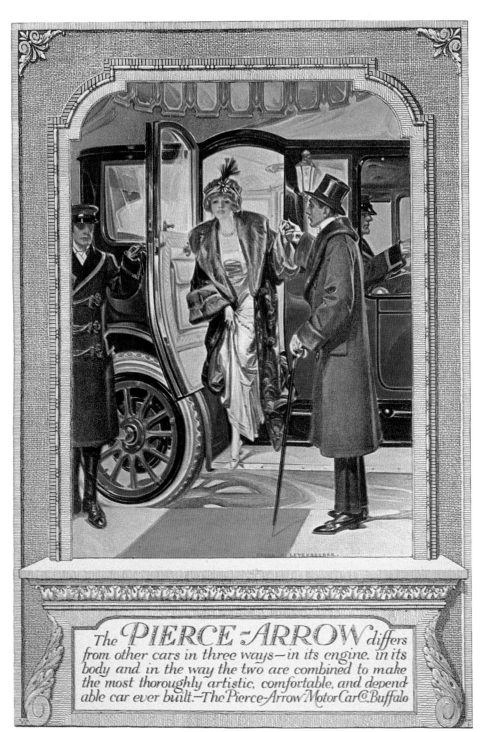

The PIERCE-ARROW differs from other cars in three ways—in its engine, in its body and in the way the two are combined to make the most thoroughly artistic, comfortable, and dependable car ever built.—The Pierce-Arrow Motor Car Co. Buffalo

PIERCE

This is a rather good picture of the Great Arrow Victoria Tonneau, 40-45 H. P., with semi-enclosed top, made by the George N. Pierce Company. Price, $5,000. Semi-enclosed top, extra, $550. Cape top, extra, $200.

FIVE thousand dollars invested in an Arrow car brings a better return for the money than twice that amount invested in a foreign car. The prestige of foreign cars, aside of course from admitted good car construction, is due to a certain sense of pride and satisfaction in owning an imported and expensive car. Every American gentleman who considers his investment in a touring car on the basis of the best return for the money will, on investigation, be convinced that the Arrow will give him more for its cost than any foreign car made. The Arrow is the highest-priced American car made. But as the American motorist learns to discriminate, he will consider the additional price a good investment when it saves both expense and worry. The chief expense of a motor car is the cost of running it. The record of the Great Arrow, in the Glidden Trophy Tour, of one thousand miles without a single adjustment, is not a phenomenal performance for the Arrow. It is something which any American gentleman, not an expert chauffeur, can duplicate with a Great Arrow car.

The Arrow, built by Americans, for American roads, American conditions and the American temperament, offers more to the non-professional American gentleman who looks to his car for enjoyment and pleasure instead of glory and expense than any other car made, foreign or domestic, high-priced or low-priced.

THE GEORGE N. PIERCE COMPANY, Buffalo, N. Y.
Member Association Licensed Automobile Manufacturers

PIERCE AGENTS

New York Harrold Motor Car Co.	Baltimore Southern Auto Co.	Springfield, Mass. . . . E. R. Clark Auto Co.
Boston J. W. Maguire Co.	St. Louis Western Auto Co.	Syracuse Amos-Pierce Auto Co.
Pittsburgh Banker Bros. Co.	Hartford Miner Garage Co.	Troy Troy Auto Exchange
Chicago H. Paulman & Co.	Kansas City . . . E. P. Moriarity & Co.	Utica Miller-Mundy M. C. Co.
San Francisco . . . Mobile Carriage Co.	Los Angeles Bush & Burge	Ottawa and Montreal . . . Wilson & Co.
Philadelphia Foss-Hughes Co.	Providence The Shepard Co.	Toronto . . . Automobile & Supply Co.
St. Paul C. P. Joy Auto Co.	Rochester U. S. Auto Co.	Denver . . . Branch The G. N. Pierce Co.
	Scranton . . . Standard Motor Car Co.	

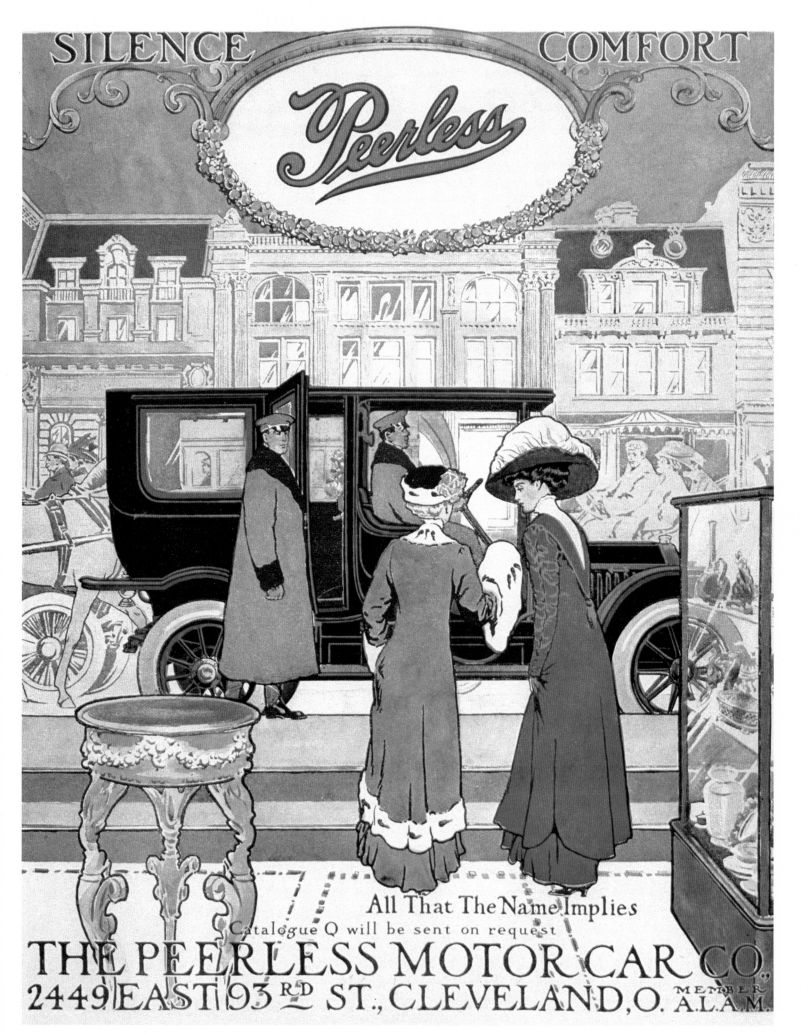

SILENCE COMFORT

Peerless

All That The Name Implies

Catalogue Q will be sent on request

THE PEERLESS MOTOR CAR CO.
2449 EAST 93RD ST., CLEVELAND, O. MEMBER A.L.A.M.

Baker Electric Vehicles
The Aristocrats of Motordom

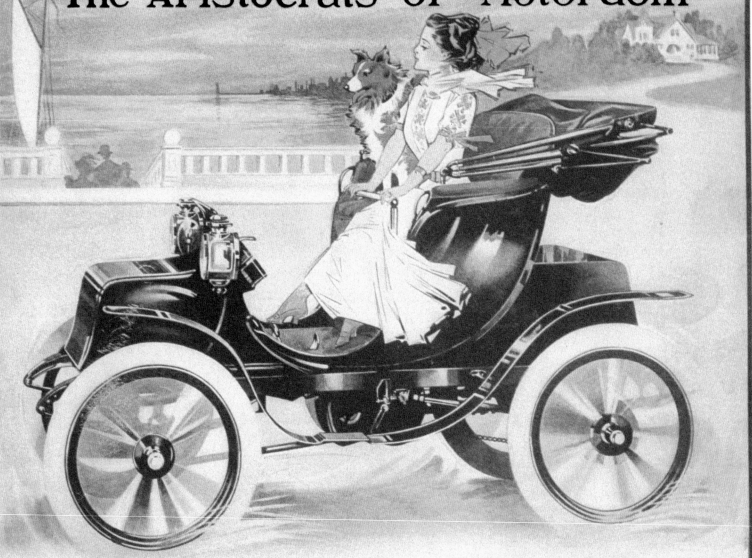

The Baker "Queen Victoria"

Baker Electrics are safest to drive—easiest to control—simplest in construction, and have greater speed and mileage than any other electrics. Where quality and efficiency are desired Baker Electrics are invariably the choice of discriminating men and women who want elegant appointments combined with mechanical perfection.

A request will bring to you our complete catalogue of Baker
Electric Runabouts, Coupés, Roadsters, Landaulets, Broughams, etc.

THE BAKER MOTOR VEHICLE COMPANY, 33 W. 80TH STREET, CLEVELAND, OHIO.
Agencies in all Principal Cities.

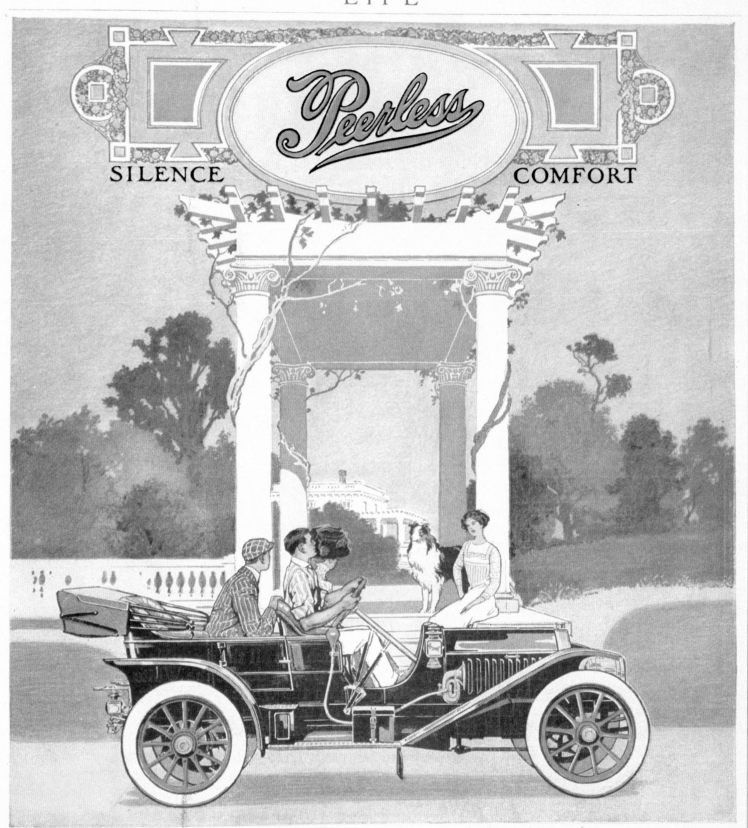

Model G—$1575
4 cyl 30 H.P.
Tonneau Included

Life holds many big days.
Two stand out prominently—

the day a man marries and the day he buys an automobile.

There is one car that ends the day of pleasure as it began it—perfectly. . . . The MAXWELL is too well known to emphasize its power, economy, comfort, reliability, prestige. . . . This is merely a reminder that here is an automobile that in price and construction has met the test that time and service demanded of it.

May we send you our latest catalogue and other literature, including two posters in colors? Drop us a postal. Just say: **"SEND COMPLETE INFORMATION."**

Perfectly Simple — Simply Perfect

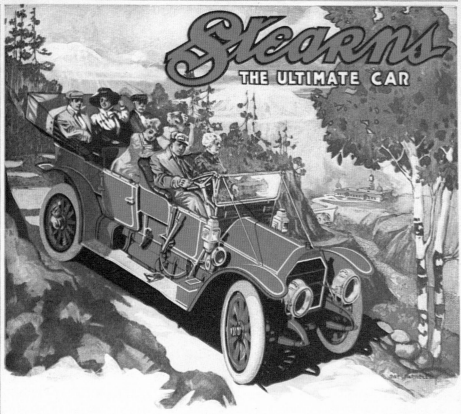

THE ULTIMATE CAR

The Stearns is a Car for *Every Purpose*

The Stearns is suited for all uses—it is not limited to any particular field. It performs as efficiently on rough mountain roads as on the boulevards; it is as ready for a trip across the continent as a spin to a suburban club. It is as well suited for social duties as for a week-end trip to some summer resort.

The Stearns has great reserve power, yet its efficiency and durability commend it no less than its luxuriousness and comfort. Simplicity and ease of control are as characteristic of the Stearns as quietness and flexibility. The car is rich and dignified, its body appointments appealing directly to those discriminating motorists who demand high grade service in every essential detail.

These features, enhanced by the great reserve power of the motor, place the Stearns on a higher plane than any other American car. Under all conditions the driver is master of the road—his car is admired and respected and always commands the right-of-way.

30-60 h. p. touring car - $4,600.00 - 15-30 h. p. touring car - $3,200.00
(Vestibule or open touring body optional)

30-60 H. P.
Model
Shaft or
Chain Drive

The F. B. Stearns Company
(Licensed under Selden Patent)
CLEVELAND, OHIO

15-30 H. P.
Model
Shaft Drive

Pacific Coast Distributing Office - - 1651 Van Ness Avenue, San Francisco, California
COPY OF OUR LATEST CATALOG, JUST ISSUED, SENT UPON REQUEST

THE WHITE LINE RADIATOR BELONGS TO THE STEARNS

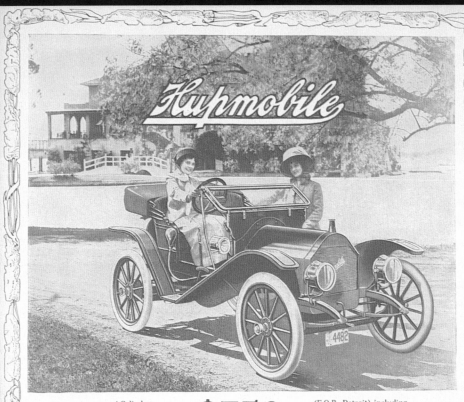

4 Cylinders
20 H. P.
Sliding Gears
Bosch Magneto

$750

(F.O.B. Detroit) including
three oil lamps, horn and
tools. Top, gas lamps and
tank, speedometer—extra.

25c. A DAY IS ALL IT COSTS MOST PEOPLE TO RUN THIS CAR

There are 7,500 Hupmobile owners in America.
The great majority keep their cars at home and run them for about 25c. a day.
That means everything—oil, gasoline, repairs—everything.
You may moralize all you like about the expense of keeping automobiles—but you'll not find a Hupmobile owner who will admit that his car is an expense at all.
At 25c. a day, he maintains that his Hupmobile is cheaper than street cars—infinitely less expensive than a horse.
Cheaper because it covers so much more ground.
An economy because it enables the owner to do two or three times as much work and still have leisure.

The Hupmobile is just the right size to save money in first cost; and it saves money, because it is just the right size, on tires, gasoline and repairs.
And isn't it the handsomest, smartest car of its type in the market?
At least 100,000 more people can afford to own a Hupmobile—in the sense that it would prove itself an actual investment in time saved and the pleasure it would bring.
Chat with a Hupmobile owner (doubtless your acquaintances include one or more). Note his enthusiastic talk. Then look up the Hupmobile dealer; or write for the catalog.

HUPP MOTOR CAR COMPANY, Dept. J. Detroit, Michigan
LICENSED UNDER SELDEN PATENT

[13]Life.1910.9.8

The Pierce Arrow

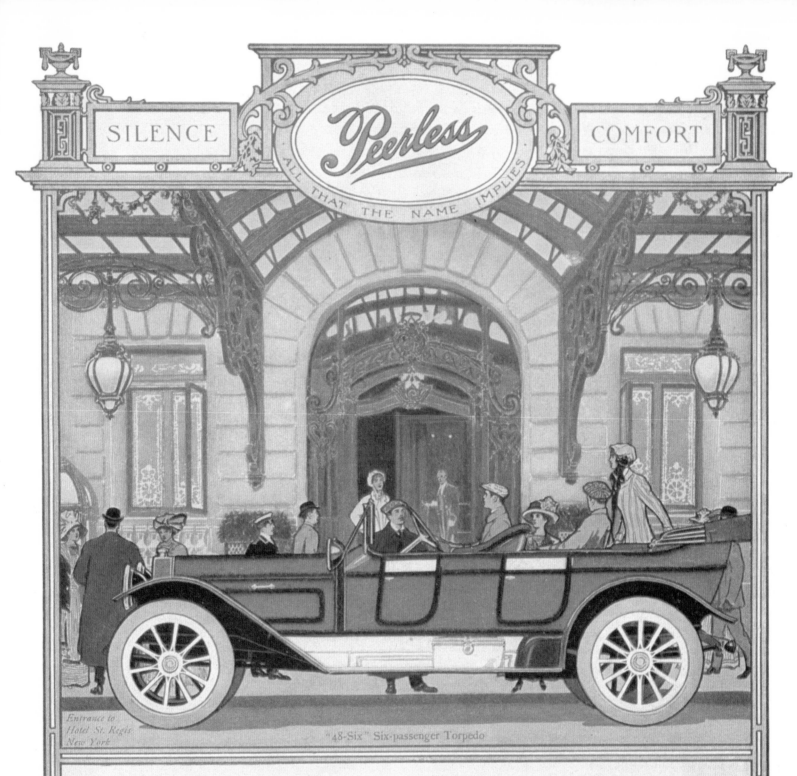

SILENCE

Peerless
ALL THAT THE NAME IMPLIES

COMFORT

Entrance to
Hotel St. Regis
New York

"48-Six" Six-passenger Torpedo

Of those material things having to do with the art of good living, there is rightly expected beauty, richness, and refinement. In a fine motor car, to produce pleasurable ease in riding, they must be combined with usefulness founded in a smooth-running mechanism.

The Peerless Motor Car Company
Cleveland, Ohio
Makers also of Peerless Commercial Cars

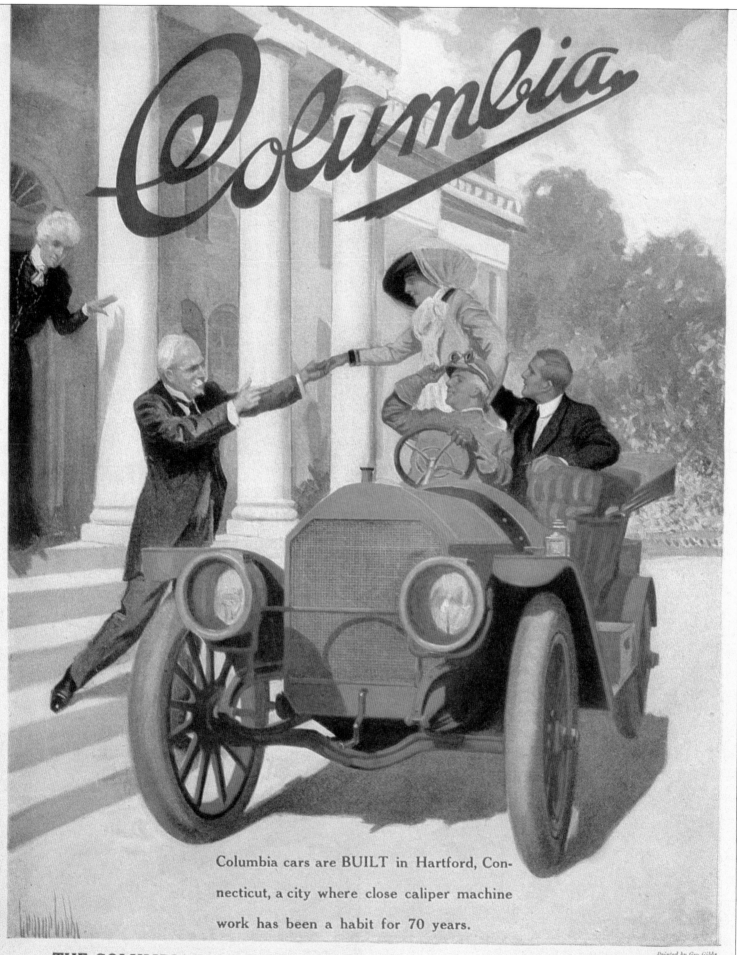

Columbia cars are BUILT in Hartford, Connecticut, a city where close caliper machine work has been a habit for 70 years.

Painted by Geo. Gibbs

THE COLUMBIA MOTOR CAR COMPANY, Station 106-A, **Hartford, Connecticut**
LICENSED UNDER SELDEN PATENT

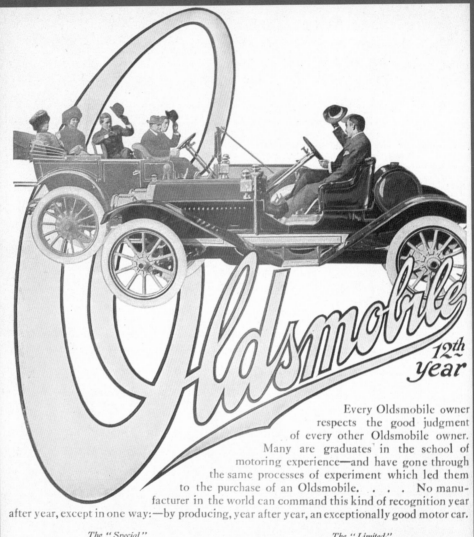

Oldsmobile 12th year

Every Oldsmobile owner respects the good judgment of every other Oldsmobile owner. Many are graduates in the school of motoring experience—and have gone through the same processes of experiment which led them to the purchase of an Oldsmobile. . . . No manufacturer in the world can command this kind of recognition year after year, except in one way:—by producing, year after year, an exceptionally good motor car.

The "Special"
4-cylinder, 40 H. P., 36-in. tires

The "Limited"
6-cylinder, 60 H. P., 42-in. tires

Touring, Close-coupled, Limousine and Roadster bodies

OLDS MOTOR WORKS, LANSING, MICHIGAN
LICENSED UNDER SELDEN PATENT

17 Life.1910.4.28

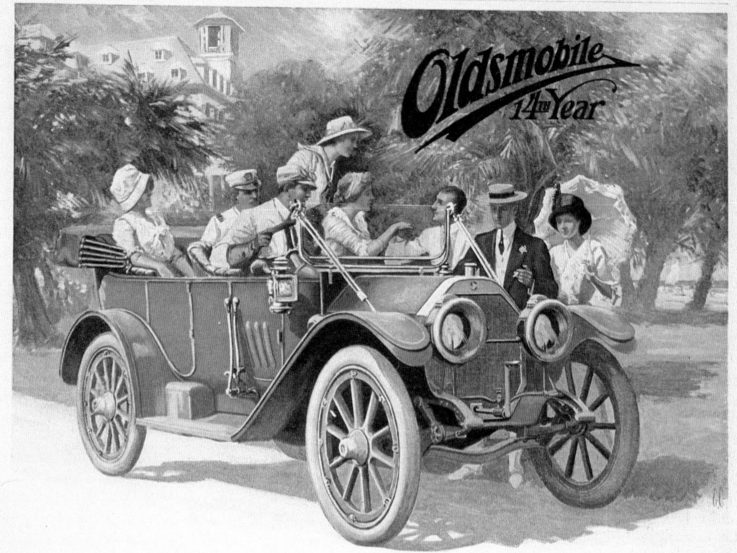

Oldsmobile 14th Year

Announcing the Defender
A new five passenger Oldsmobile

We have been well aware of the demand for a smaller Oldsmobile than the Autocrat; a five-passenger touring, with proportionately less horse power—but *a car of Oldsmobile quality throughout.* The Defender is ready to fulfill this demand.

For many months the first Defenders built have been tried out over all kinds of roads, good and bad, day after day. We delayed announcement and deliveries until the car was pronounced "perfection," not only by our mechanical staff, but by every officer and department head.

The Defender is a very handsome, four-cylinder 35 H.P. car of moderate weight. It is roomy, low-hung, luxuriously comfortable and worthy in every particular of the name Oldsmobile.

A glance at some of the specifications will show the mechanical reasons for its exceptional motor efficiency and its easy riding qualities.

4-cylinder, T-head, long-stroke motor; Bore 4 in., Stroke 6 in.
Dual Ignition System.
4-Speed Transmission; of Chrome Vanadium steel; ball bearings throughout.
Double drop frame of nickel steel.
Straight line drive; shaft enclosed in torsion tube.
Long, easy-acting springs; ¾ elliptic over rear axle.
Shock absorbers of standard type both front and rear.
Improved Bolted-on Demountable Rims.
36 x 4 in. Tires on open models.
34 x 4½ in. on Coupé.

Five-passenger Touring, four-passenger Tourabout, two-passenger Roadster and three-passenger Coupé bodies of latest design. Ventilators in fore-doors, opened or closed by a touch.
Nickel and Black Enamel finish on metal parts.
Top and Top Boot; wind shield, speedometer; electric and oil side and rear lights; automatic lighter, for headlights, operated from driver's seat; Prest-O-Lite tank and a number of conveniences found only in the most expensive cars, are included as regular equipment.

It should be understood that the Defender is not a "cheaper" Oldsmobile. It is of precisely the same high quality in materials, workmanship, finish and equipment as our $3500 and $5000 cars. It is not a successor to the Autocrat or Limited; it is their younger brother. The type shown above costs $3000, completely equipped. It will satisfy the man who is willing to pay enough to get the very best.

Further particulars and illustrations on request.

OLDS MOTOR WORKS **LANSING, MICHIGAN**

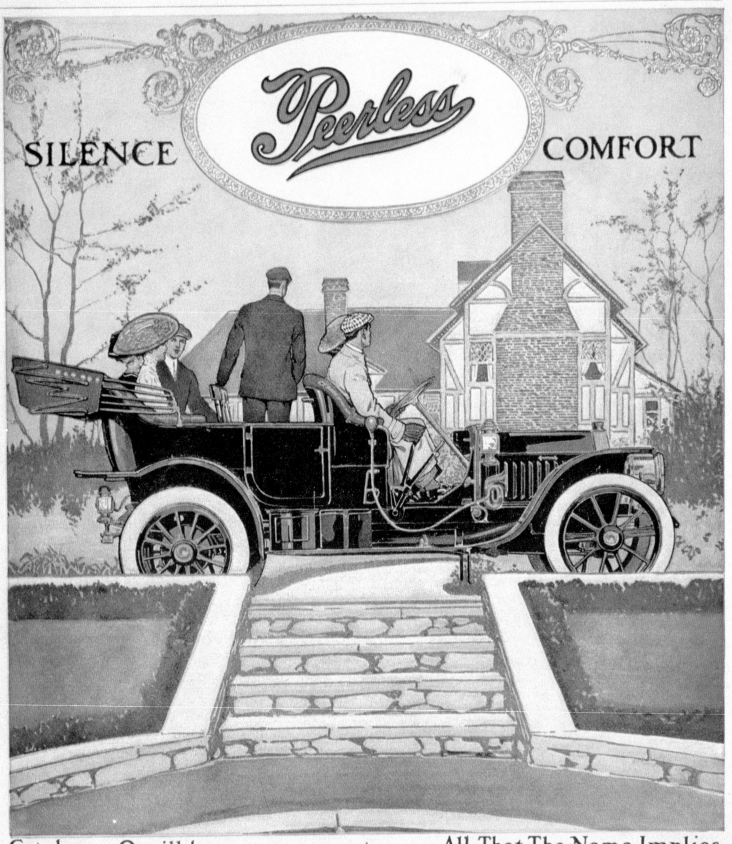

SILENCE COMFORT

Catalogue Q will be sent on request All That The Name Implies

THE PEERLESS MOTOR CAR CO.,
2449 EAST 93RD ST., CLEVELAND, O.
LICENSED UNDER SELDEN PATENT

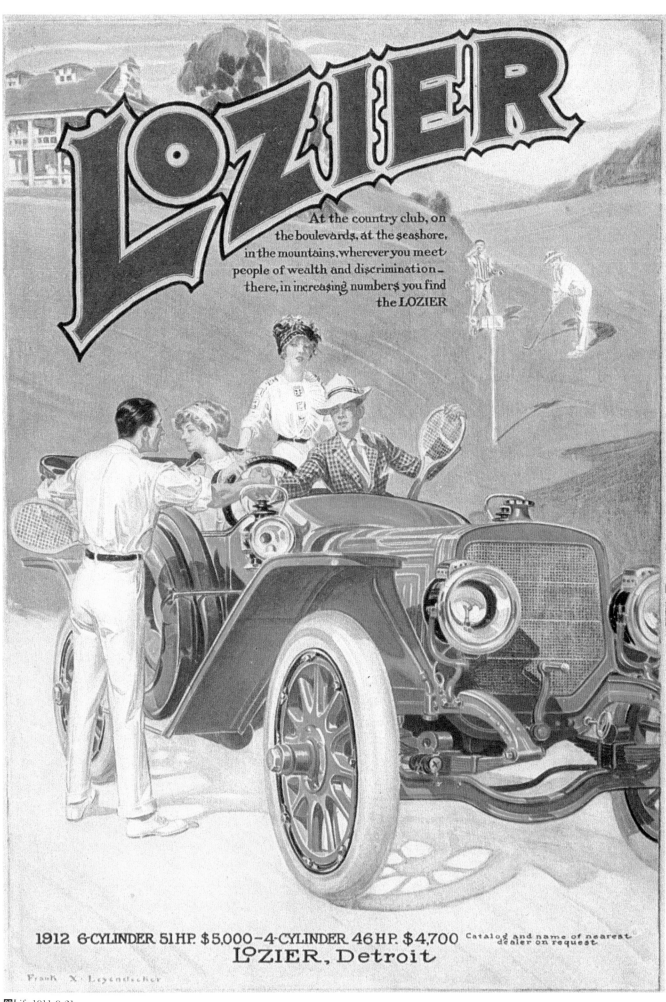

LOZIER

At the country club, on the boulevards, at the seashore, in the mountains, wherever you meet people of wealth and discrimination — there, in increasing numbers you find the LOZIER

1912 6-CYLINDER 51 H.P. $5,000—4-CYLINDER 46 H.P. $4,700 Catalog and name of nearest dealer on request

LOZIER, Detroit

Frank X. Leyendecker

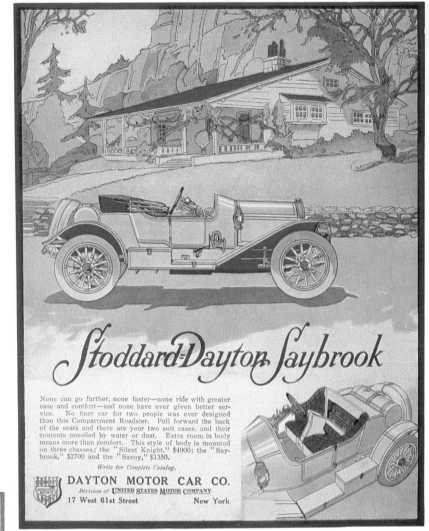

21 Life,1912.1.4

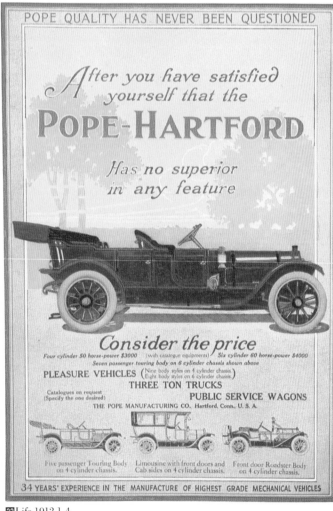

22 Life,1912.1.4

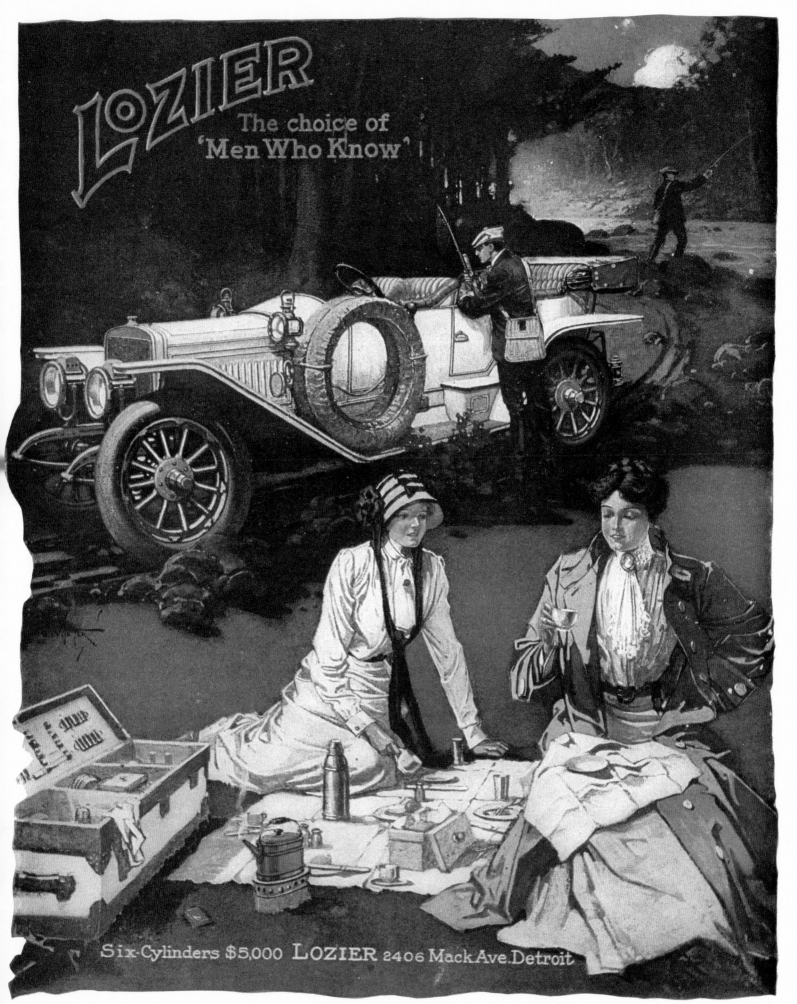

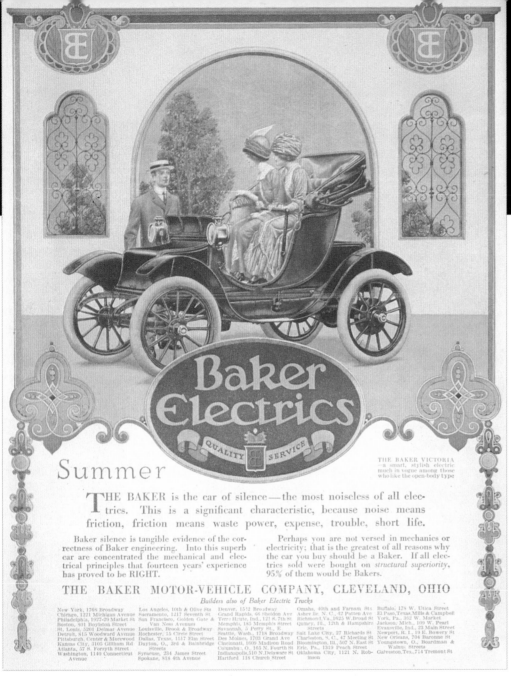

THE BAKER VICTORIA
—a smart, stylish electric much in vogue among those who like the open-body type

Summer

THE BAKER is the car of silence—the most noiseless of all electrics. This is a significant characteristic, because noise means friction, friction means waste power, expense, trouble, short life.

Baker silence is tangible evidence of the correctness of Baker engineering. Into this superb car are concentrated the mechanical and electrical principles that fourteen years' experience has proved to be RIGHT.

Perhaps you are not versed in mechanics or electricity; that is the greatest of all reasons why the car you buy should be a Baker. If all electrics sold were bought on *structural superiority*, 95% of them would be Bakers.

THE BAKER MOTOR-VEHICLE COMPANY, CLEVELAND, OHIO

Builders also of Baker Electric Trucks

The Newest Development by the Oldest, the Largest, the Foremost Electric Automobile Manufacturers in the World.

A Coupé of Unequ[alled]

IMAGINE the most beautiful [...] the most exquisite craftsman[ship]

Then you have a faint conc[eption of the] comfort, richness and dignity of [...]

With its increased roominess, its full limousine [...] its longer wheel base and graceful, low-hung body [...] this magnificent new model thoroughly satisfies the [...] taste for a stylish yet conservative coupe.

On both interior and exterior have been lavish[ed] the refinements of convenience and appointment dem[anded] by so beautiful a car. One of its innovations is the r[...] ing front seats, enabling the forward occupants to fa[ce ...]

THE BAKER MOTOR-VEHI[CLE]

Builders [...]

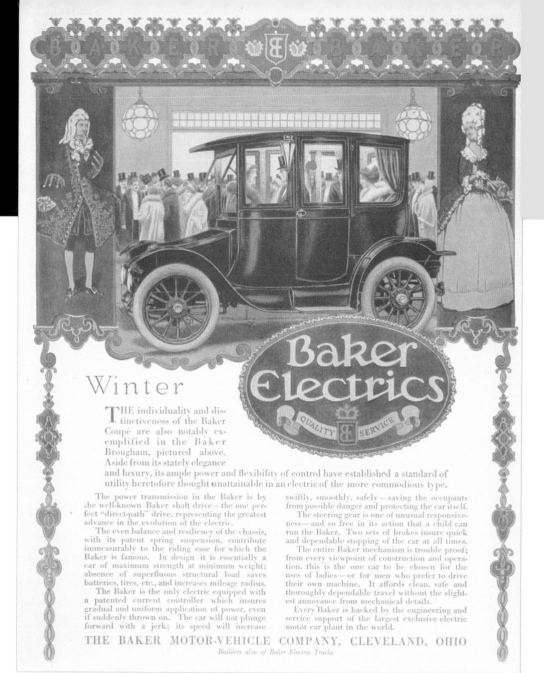

The Selden Patent — The Story of a Lawyer Who Earned Enormous Patent Fees for One Blueprint

After seeing a model of a two-cycle-engine car on display at the 1876 Philadelphia World's Fair, young lawyer George B. Selden (1846–1922) predicted that automobiles powered by gasoline engines would soon replace horse-drawn carriages as a means of transportation.

Selden was so confident in his conviction that he went home and immediately drew a simple blueprint (see drawing) of a gasoline-engine-run automobile, known then as a "road engine car," and applied for a patent. His petition, remarkably, was accepted, and by 1895, car manufacturers owed a patent fee to Selden for each car produced in the United States with a gasoline engine.

In response to the patent, American car makers formed the Association of Licensed Automobile Manufacturers (ALAM) to negotiate with Selden on the amount of the fee. The compromise reached was five dollars per car. ("Licensed Under Selden Patent" or "Member A.L.A.M" printed in the antique car ads acknowledges the patent.)

Finally in 1911, Henry Ford sued, and the patent right was voided. By then, Selden had enjoyed a sixteen-year profit from patent fees.

every Thursday. Annual Subscription Dollars. Single Copies, Ten Cents. in England and the British Possessions

Entered at the Post Office at New York, N. Y., as Second Class Mail Matter

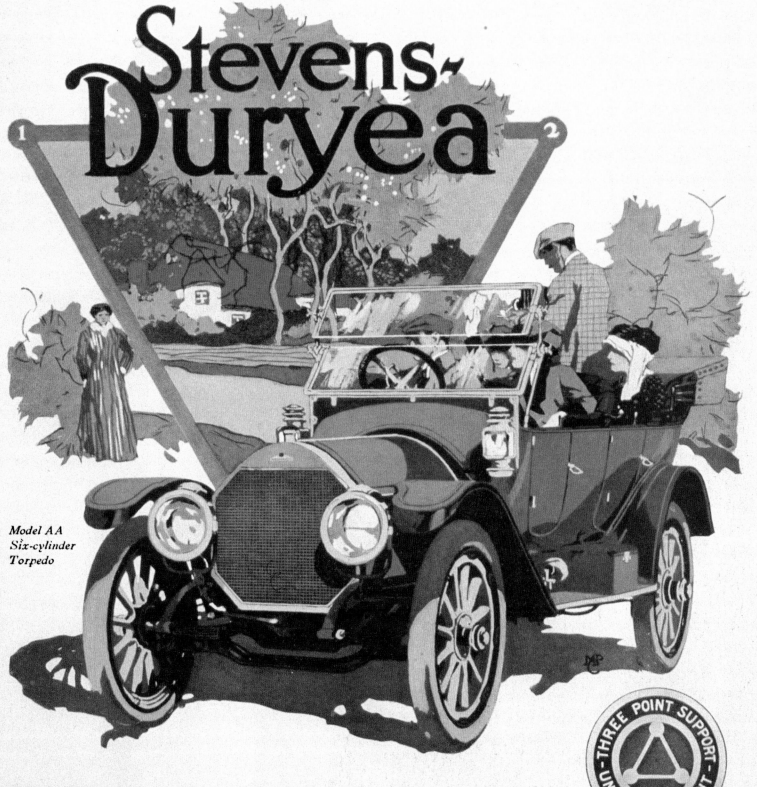

Stevens-Duryea

Model AA Six-cylinder Torpedo

THREE POINT SUPPORT · UNIT POWER PLANT

TWENTY-ONE years of consistent progress have resulted in the distinctive individuality for which Stevens-Duryea motor cars are famed—individuality of mechanical design, individuality of finish, and individuality of service.

Our "Individuality" booklet will interest you. Send for it.

STEVENS-DURYEA COMPANY, Chicopee Falls, Massachusetts

Pioneer Builders of American Sixes

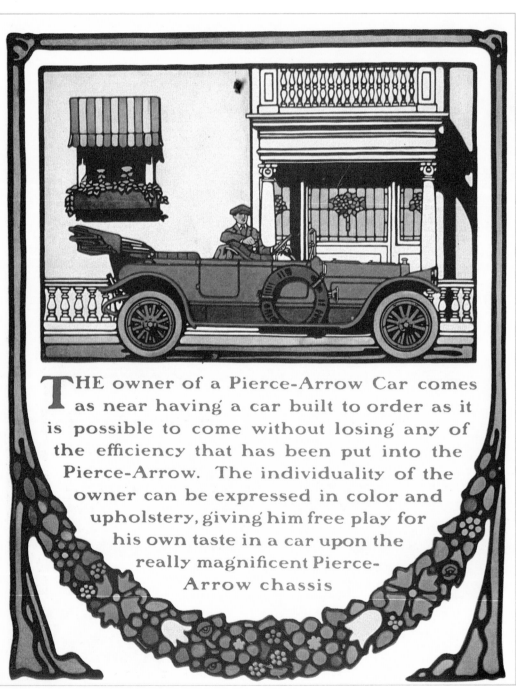

THE owner of a Pierce-Arrow Car comes as near having a car built to order as it is possible to come without losing any of the efficiency that has been put into the Pierce-Arrow. The individuality of the owner can be expressed in color and upholstery, giving him free play for his own taste in a car upon the really magnificent Pierce-Arrow chassis

Not only has th
the tide of impo
are today far l
some years ago-
Pierce-Arrow in
invaded Europe
tion to its owne
its native heath.

The Pierce-Arrow Moto

ce-Arrow turned
ars so that there
proportion than
nly that, but the
rican hands has
greater satisfac-
a native car on

pany, Buffalo, New York

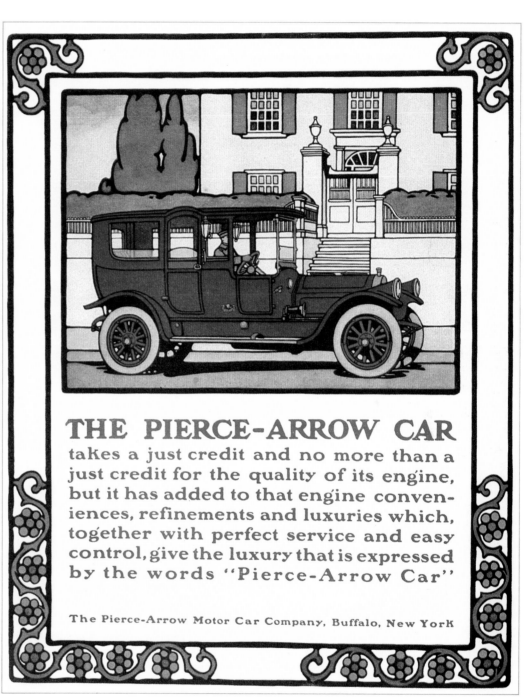

THE PIERCE-ARROW CAR

takes a just credit and no more than a
just credit for the quality of its engine,
but it has added to that engine conven-
iences, refinements and luxuries which,
together with perfect service and easy
control, give the luxury that is expressed
by the words "Pierce-Arrow Car"

The Pierce-Arrow Motor Car Company, Buffalo, New York

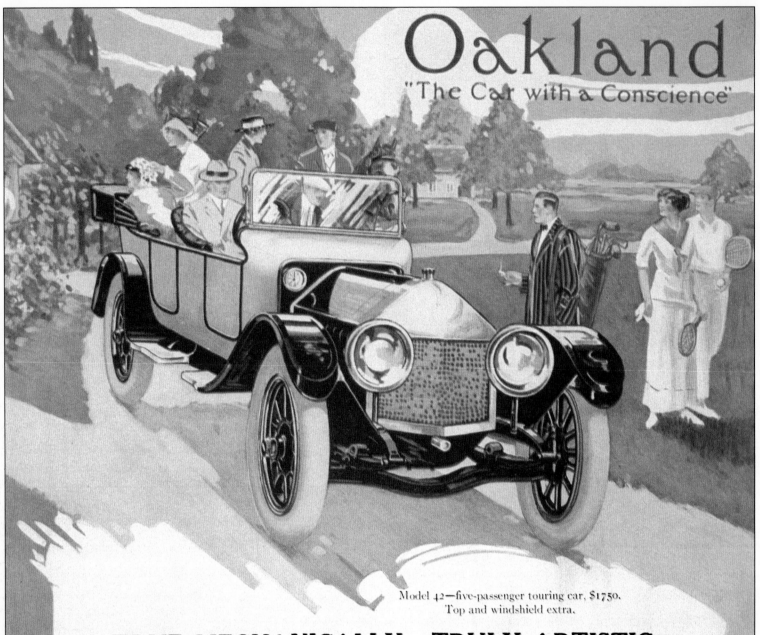

Oakland
"The Car with a Conscience"

Model 42—five-passenger touring car, $1750.
Top and windshield extra.

TRUE MECHANICALLY—TRULY ARTISTIC

⊄ In 1913 Oaklands beauty is given a new charm, luxury a new significance and individuality a new meaning.

⊄ All that you care for in a motor car is found in the Oakland. All of the best and certain of the old and all that is safe and beautiful in the new, has found a place in the Oakland for 1913.

⊄ Fours and Sixes, in a wide range of body designs. $1000 to $3000.

The Greyhound 6-60—wheel base 130 inches, double drop frame, unit power plant, cone clutch, sliding gear transmission, full floating rear axle, demountable rims, "V" shaped German silver radiator, 10-inch upholstering, full nickel trimmings and equipped with the improved Delco electric starting, lighting and ignition system, $2550. (Top and windshield extra.) There is mounted on this chassis four, five and seven passenger bodies and a raceabout for two. Price of all models the same.

Model 42 Chassis—116 inch wheel base, double drop frame, unit power plant, cone clutch, sliding gear transmission, full floating rear axel, demountable rims, "V" shaped German silver radiator, 10-inch upholstering, full nickel trimmings and equipped with the improved Delco electric starting, lighting

and ignition systems, $1750. (Top and windshield extra.) There is mounted on this chassis a five passenger body, a close coupled four passenger body and the famous Sociable Roadster (three passenger—single seat). Price of all models the same. There is also built a smart four passenger coupe on this chassis selling for $2500.

Model 35 Chassis—five passenger touring car, wheel base 112 inches, unit power plant, demountable rims, storage battery for electric lighting, nickel trimmings, $1075. We are also building on this chassis a three passenger Sociable Roadster, at $1000. Model 35 will be equipped with electric lighting and ignition system and air starter at a nominal charge.

Write Dept. 120 for Catalogue and Booklets "What the Car with a Conscience Stands For" and "The Oakland Your Car for 1913."

OAKLAND MOTOR CAR COMPANY,
PONTIAC, MICHIGAN.

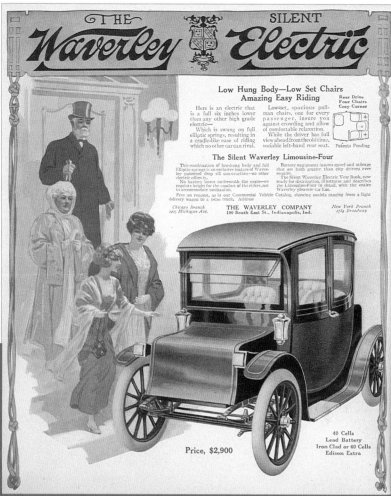

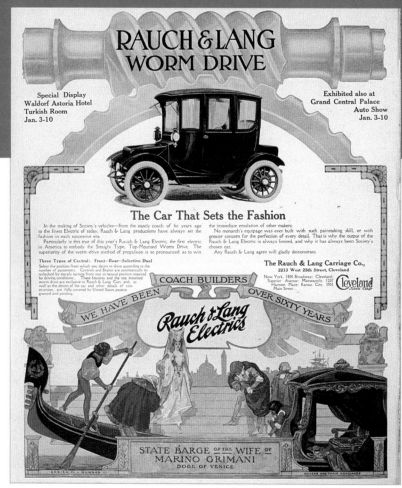

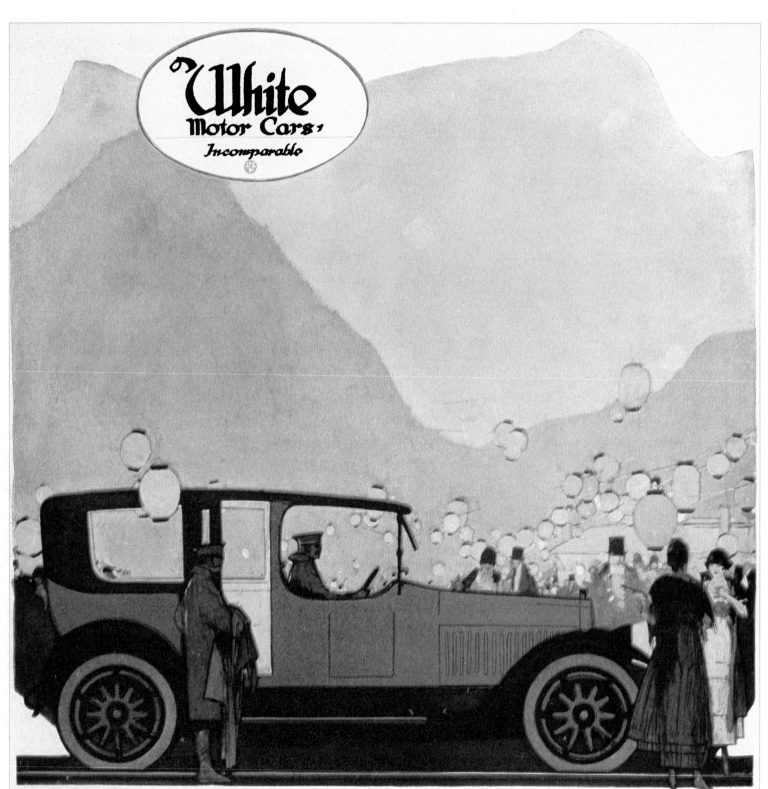

The fine enclosed car holds an important place in the environment of those whose choice in all things denotes cultured discrimination. To such persons the enclosed car must be more than simply a conveyance—it must express cultivation of taste—it must be fashionable in the truest sense—it must bespeak the personality of the owner. White enclosed cars are custom-built, affording you the opportunity to collaborate with our designers in having the finish and decorations identified with your own personal taste. Let us submit plans for your new enclosed car—Limousine, Landaulet, Semi-Touring or Town Car. Fall delivery assured on orders placed now.

The WHITE COMPANY, *Cleveland, Ohio*

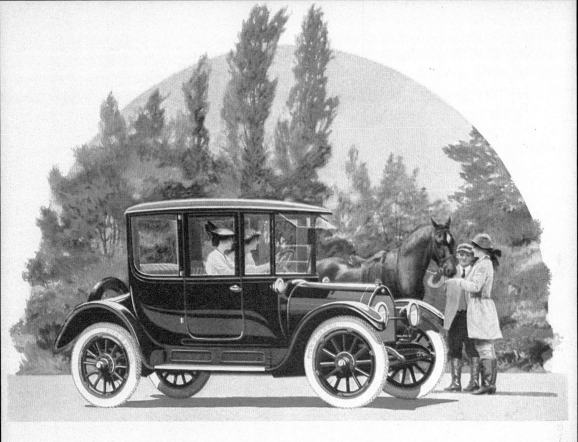

The Coupe With Noiseless Motor $1500

f. o. b. Toledo

The Willys-Knight Coupe is by far the most desirable closed car of the season.

The famous Knight type motor is quiet and vibrationless because it has sleeve valves. Standing right next to the hood one can scarcely tell whether or not it is running. Thus you get the absolute quietness of an electric plus the usefulness, service and unlimited mileage of a high powered automobile.

This coupe has charm and beauty. Soft gray Bedford cord cloths line the interior.

The graceful coach design is finished in dark tone of deep Royal blue. Inside and out you will find exquisite smartness.

Any woman can drive this car.

The Willys-Knight coupe will be the popular car among womenfolks for the coming season.

The production on this model is limited. Orders placed immediately will receive preference.

Catalogue on request. Please address Dept. 378.

Coupe
$1500
f. o. b. Toledo

THE WILLYS OVERLAND CO.
Willys
KNIGHT
TOLEDO, OHIO.

Limousine
$1750
f. o. b. Toledo

Also Manufacturers of the famous Overland Automobiles.

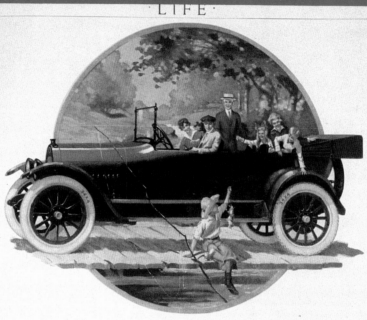

Make Certain of *Your* Jeffery Now

THE joys of Jeffery ownership are not for everybody this year—a Jeffery shortage is an assured fact.

Now, when Nature is just beginning to smile, is the time to assure yourself this privilege, and throughout all the golden days of Spring and Summer you will realize to the full your perfect satisfaction in your purchase.

Your judgment in selecting the car which introduced the high-speed, long-stroke, high-efficiency motor to America will be justified daily by actual performance in comparison with the products of other factories which have followed the Jeffery example.

From radiator to rear axle you will find a multitude of other evidences of Jeffery leadership—made possible because the car has been developed by Jeffery engineers, and is built, practically in its entirety, in the Jeffery factory. You will be satisfied with the car as a unit because the car has been built as a unit to satisfy you.

An early visit to your Jeffery dealer will insure *you* this satisfaction—and at the very time of the year when motoring is most delightful.

THE JEFFERY FOUR		THE NEW JEFFERY SIX
Seven Passenger Touring $1035		A light-weight Six, of distinctive beauty and sur-
Without auxiliary seats 1000		passing comfort — with practically unlimited
Three Passenger Roadster 1000		power and speed $1450
Sedan—top removable, summer top included . . 1165		(Prices F. O. B. Kenosha, Wis.)

BOOKLET ON REQUEST

The Thomas B. Jeffery Company
Main Office and Works, Kenosha, Wisconsin

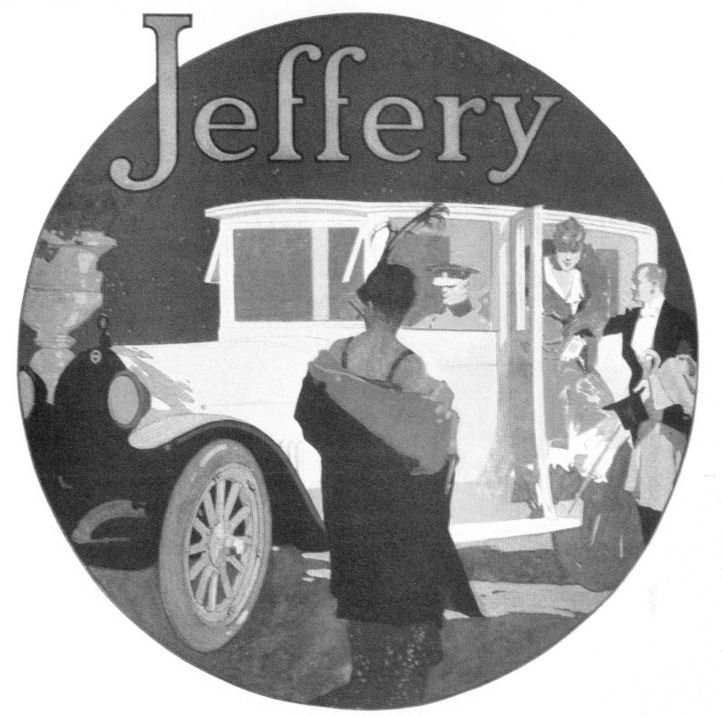

Here Is Hospitality

Truly, a needful auxiliary to the modern home is this luxurious Jeffery Sedan! Like the home, its hospitality invites, its distinctive appointments charm and its all-weather welcome beckons.

There is a kindly bond of attachment between this year-'round carriage and its owners. To the family it is the ready means of spanning distance between home and destination.

Its long-grain leather upholstery invites luxurious ease. Through finest French plate, you enjoy a wide field of vision, while special construction features give the Sedan decided advantages over the limousine type. Pleasing among these is the noiseless gliding along, which endures through the life of the car.

All these contribute to the mental and physical repose of the passenger. Dignity and prestige attend such travel.

Designed for both the Jeffery Four and Six, with top removable—converted readily into an open touring car.

SIXES: Sedan, $1530. Touring, $1365. Roadster, $1335. FOURS: Sedan, $1260. Touring, $1095. Roadster, $1065. F.O.B. Kenosha.

THE NASH MOTORS COMPANY, KENOSHA, WISCONSIN, U. S. A.

Manufacturers of Jeffery Motor Cars and Trucks including the Famous Jeffery Quad

Quality First

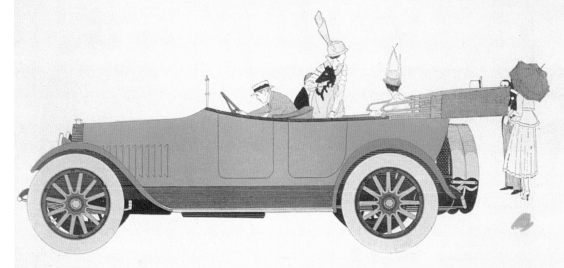

THE CHALMERS SIX-40 TRANSMUTES USELESS MIGHT INTO "PEPPERY" PICK-UP AND OPERATING ECONOMY

She's a seven-passenger—this car that put the good word "spunk" into the motor language.

A little larger than her better-known sister, the 3400 r.p.m. Chalmers.

She gets away with eager assurance, like a sunbeam. She accelerates with rare swiftness and sparkle.

You're running along easily. The speedometer needle is around 10 miles an hour. Now throw out your clutch. See how nicely her gears and differential play together?

Now let in your clutch. And there's never a fret or jar. You don't feel as if you'd come down on the footbrake by mistake.

Her performance is full of the glow that restoreth the soul.

To describe her riding comfort in terms of specifications of springs and upholstery is like describing a sunset as red.

The freedom of her engine—the remarkable delivery of dynamic energy to her rear wheels comes from overhead cams in a valve-in-head type of engine.

It's the same type of engine that heaves thrills into the race-fans at Sheepshead Bay.

But here it's checked down for road use, so that a woman dare drive. No reckless, alarming presence of superfluous force.

While she won't deliver that treacherous, perilous, tire-burning pace that the speedways prize, she'll come clean with 60 miles an hour any time you say. But why 60?

The useless might of her potent engine has been sheared away and rewoven into fox-footed acceleration and operating economy.

At 5, 10, 20, and 30 miles an hour—at all practical and sensible speeds—is where you need "peppery" pick-up the most. And hers responds like a spark to the flint every time another car's dust gets in your eyes, every time you hit a grade, every time you turn a corner.

She has beauty to match the glamour of performance. Clothed in Valentine Green—Meteor Blue—or Oriford Maroon with a gold stripe around the body—and wheels dark, primrose, or red, there's a beckoning lure in every line.

All of which accounts for why so many of your friends are going Chalmers

$1450 Detroit
$1950 in Canada

Chalmers Motor Company Detroit, Michigan

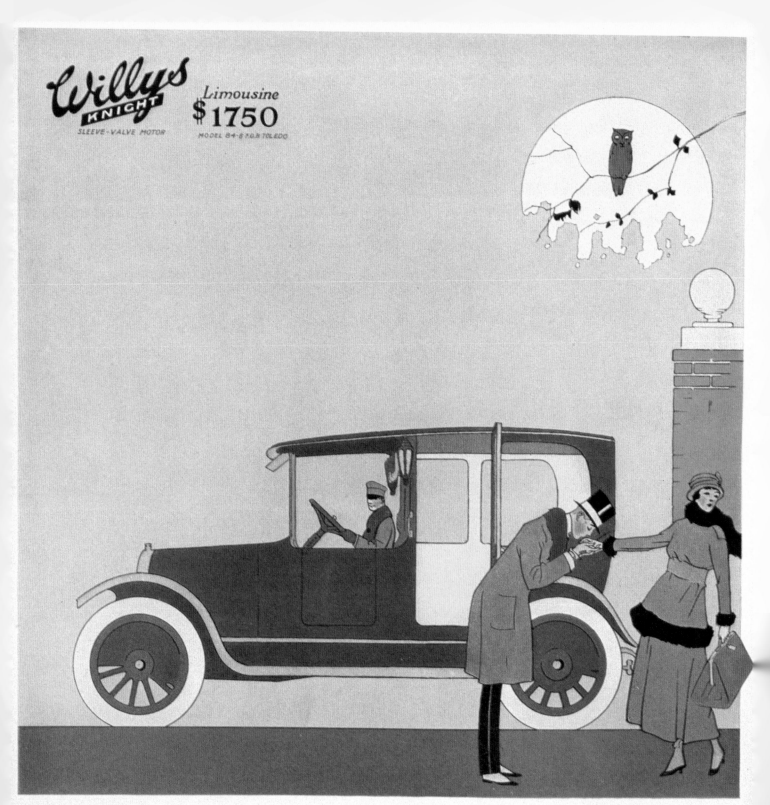

Willys KNIGHT
SLEEVE-VALVE MOTOR

Limousine
$1750
MODEL 84-8 F.O.B TOLEDO

THIS is a *doubly* distinguished car.

It has that smartness of style which pride demands in a limousine.

But it is distinguished not only by its beauty of design and finish:—

It has a motor equipment which gives it a more lasting usefulness.

In proportion to your greater investment in a closed car it should serve you longer.

So our closed cars are equipped with Knight-Type, sliding sleeve-valve motors.

These motors, quieter than others when new, become *more and more* quiet with use.

More powerful and more flexible than others when new, they *increase* in power and flexibility with use.

This betterment with use exactly reverses your experience with any other type of motor.

See this car and test it.

Other Willys-Knight Cars are the Coupe $1500, the Touring Car $1125 and the Roadster $1095—all prices f. o. b. Toledo.

Overland dealers gladly show these cars and demonstrate them.

The Willys-Overland Company, Toledo, Ohio

"Made in U.S.A."

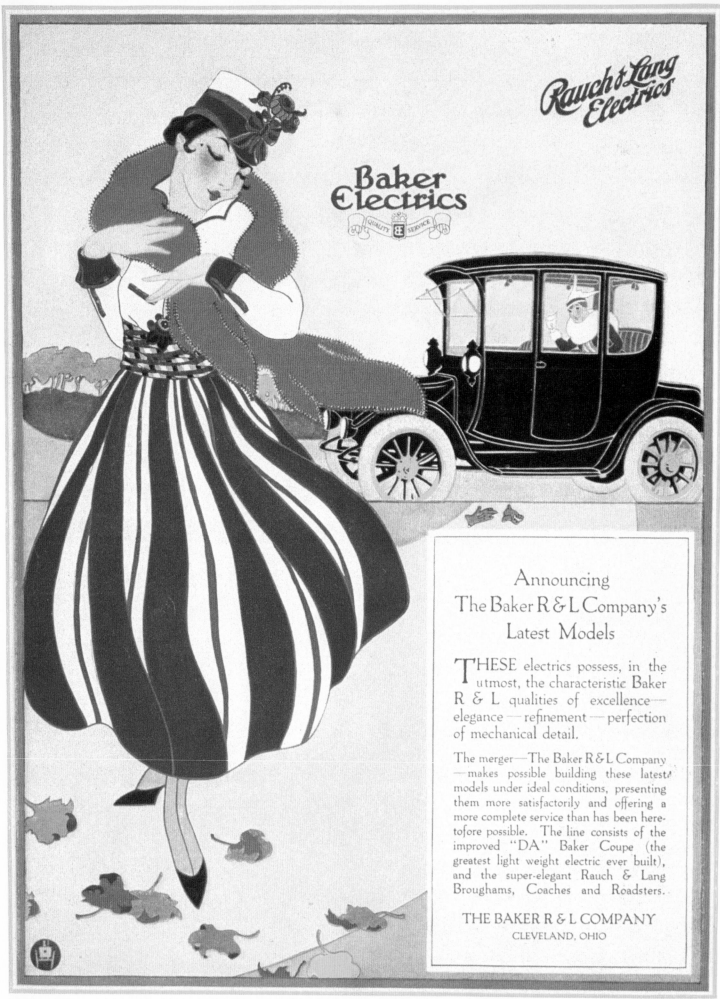

Rauch & Lang Electrics

Baker Electrics
QUALITY · SERVICE

Announcing
The Baker R & L Company's
Latest Models

THESE electrics possess, in the
utmost, the characteristic Baker
R & L qualities of excellence —
elegance — refinement — perfection
of mechanical detail.

The merger — The Baker R & L Company
— makes possible building these latest
models under ideal conditions, presenting
them more satisfactorily and offering a
more complete service than has been here-
tofore possible. The line consists of the
improved "DA" Baker Coupe (the
greatest light weight electric ever built),
and the super-elegant Rauch & Lang
Broughams, Coaches and Roadsters.

THE BAKER R & L COMPANY
CLEVELAND, OHIO

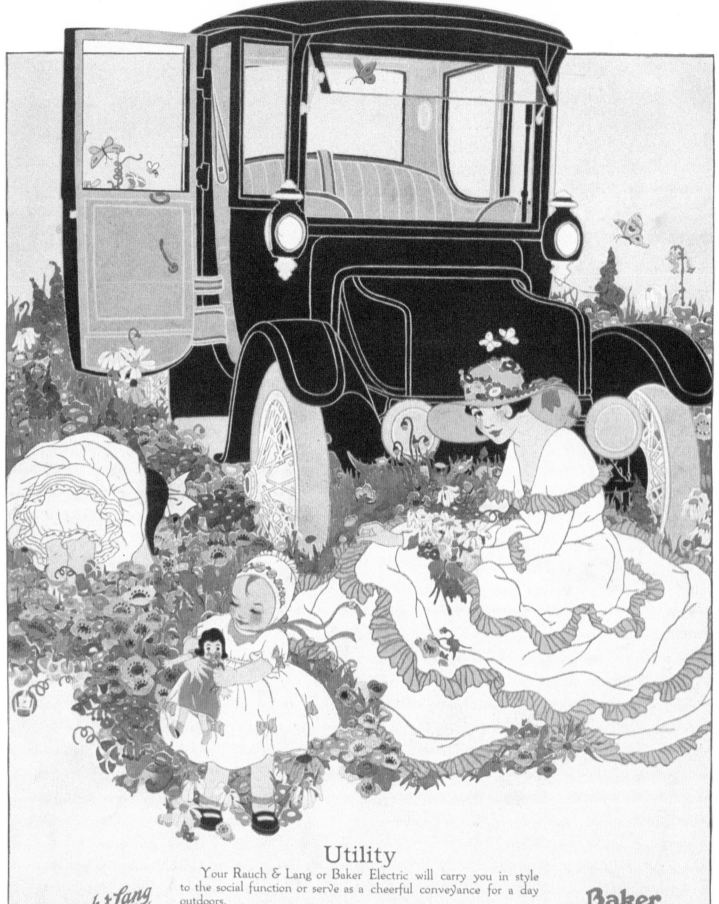

Utility

Your Rauch & Lang or Baker Electric will carry you in style
to the social function or serve as a cheerful conveyance for a day
outdoors.

The wonderful ease of control—the silent, efficient, depend-
able motor—and the genuine Coach Work—all these unite in
making your Rauch & Lang or Baker Electric a Car of Utility and
Enjoyment.

*Rauch & Lang
Electrics*

"The Social Necessity"

Baker
Electrics

THE BAKER R & L COMPANY
Cleveland, Ohio

Henry Ford and the Model T

Many great achievers are known for their stubborn individuality and strong character, and Henry Ford, the founder of Ford Motors, is a perfect example of such a personality.

His achievements, of course, are legendary. Twenty years after Ford produced the first Model T in 1908, fifteen million Model T's were on the road. They were practical cars and had something else in common—all fifteen million were painted black. In an attempt to respond to growing consumer demand, one Ford executive in the late twenties stated, "We must produce red, green, and yellow car body colors or our customers will be snatched up by other companies." Ford replied, "Any color the customer wants, so long as it is black."

In response to the accusation that the Model T's did not have shock absorbers, Ford said that "they have shock absorbers—the passengers."

A person who disliked publicity, Henry Ford believed that quality cars had no need of advertising and that advertising was, in fact, wasteful. Only four Ford ads (Figures 54 through 57) appear in this book, and all date from the later days of the Model T.

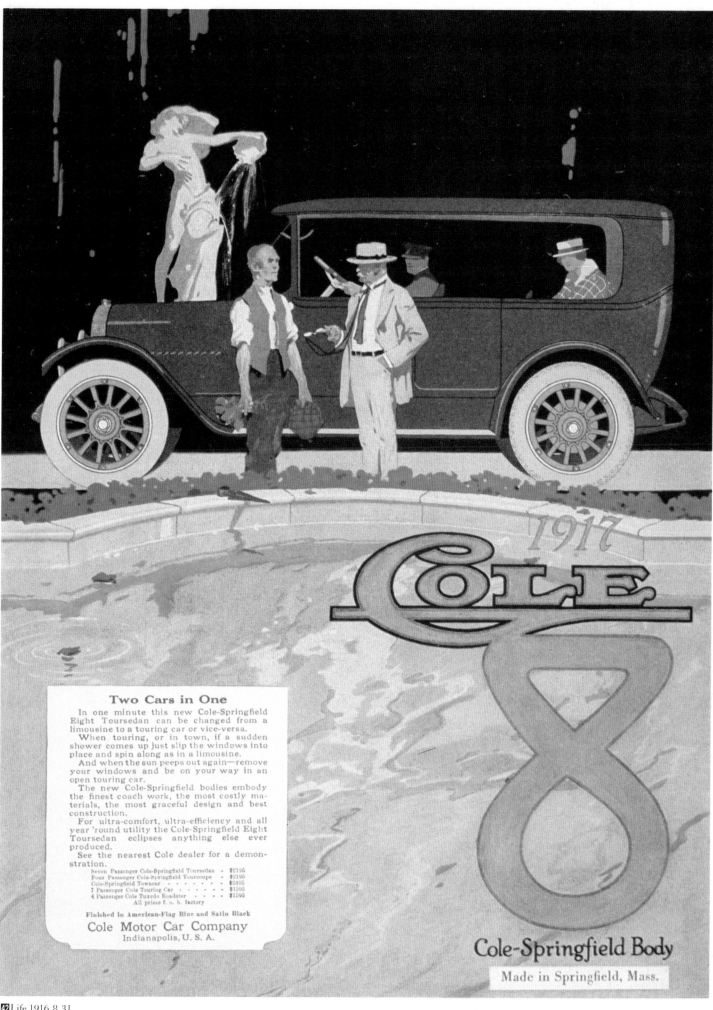

1917

COLE

8

Two Cars in One

In one minute this new Cole-Springfield Eight Toursedan can be changed from a limousine to a touring car or vice-versa.

When touring, or in town, if a sudden shower comes up just slip the windows into place and spin along as in a limousine.

And when the sun peeps out again—remove your windows and be on your way in an open touring car.

The new Cole-Springfield bodies embody the finest coach work, the most costly materials, the most graceful design and best construction.

For ultra-comfort, ultra-efficiency and all year 'round utility the Cole-Springfield Eight Toursedan eclipses anything else ever produced.

See the nearest Cole dealer for a demonstration.

Seven Passenger Cole-Springfield Toursedan	$2195
Four Passenger Cole-Springfield Tourcoupe	$2195
Cole-Springfield Towncar	$2495
7 Passenger Cole Touring Car	$1595
4 Passenger Cole Tuxedo Roadster	$1595
All prices f. o. b. factory	

Finished in American-Flag Blue and Satin Black

Cole Motor Car Company
Indianapolis, U. S. A.

Cole-Springfield Body

Made in Springfield, Mass.

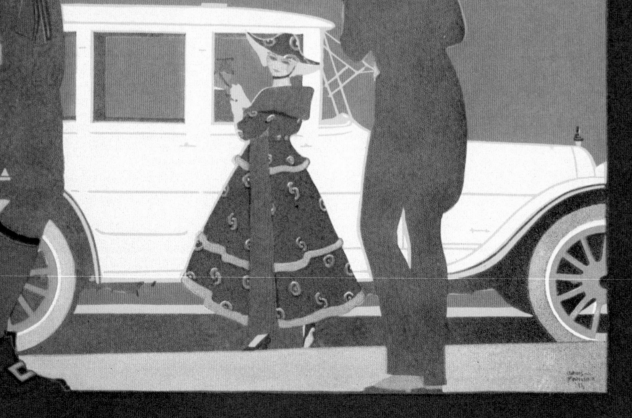

Simplex

IN motors, as in clothes, the most admired and copied are those expressing the refinement and exclusiveness of the made to order. Simplex, Crane Model, 6 cylinder—Chassis $6000.

Bodies to Order

SIMPLEX AUTOMOBILE CO.
60 Broadway New York

CLASSIC CARS
1919–1936

Although the ads in this book do not go beyond 1936,

any automobile made from 1919 through 1939 (the twenty years between

World War I and World War II) is classified as a classic car.

The cars most commonly referred to as classics, due to their high-speed

engines and beautiful styling, are those produced

between 1919 and 1930.

●

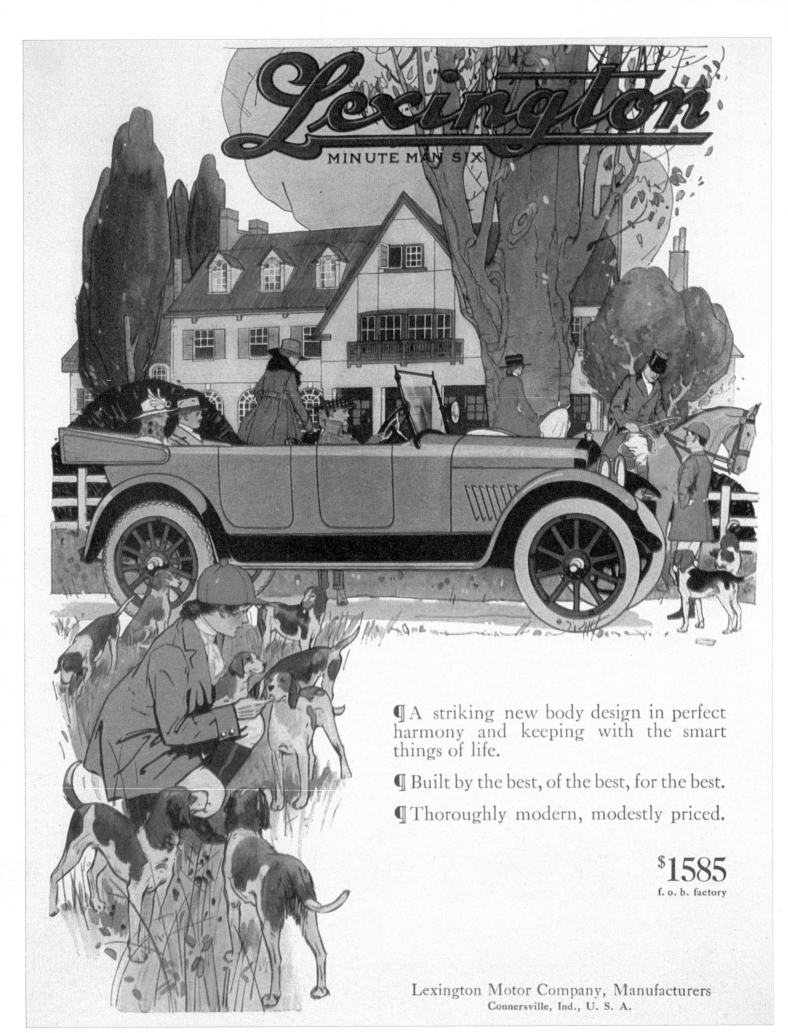

Lexington
MINUTE MAN SIX

¶ A striking new body design in perfect harmony and keeping with the smart things of life.

¶ Built by the best, of the best, for the best.

¶ Thoroughly modern, modestly priced.

$1585
f. o. b. factory

Lexington Motor Company, Manufacturers
Connersville, Ind., U. S. A.

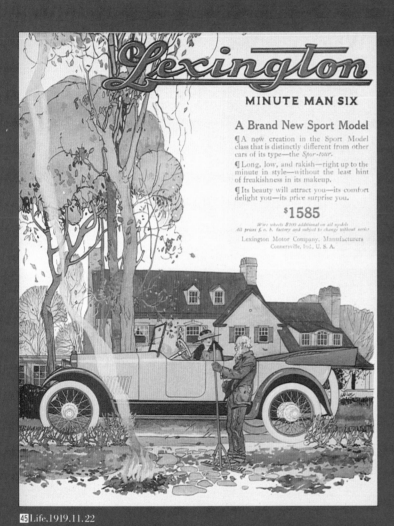

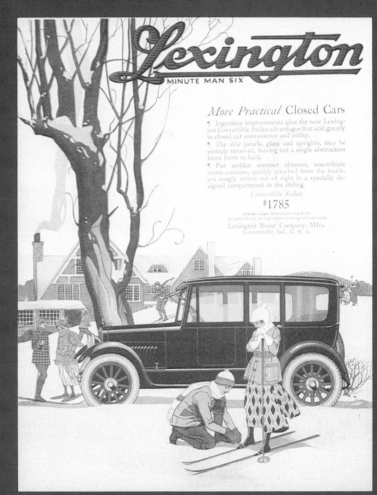

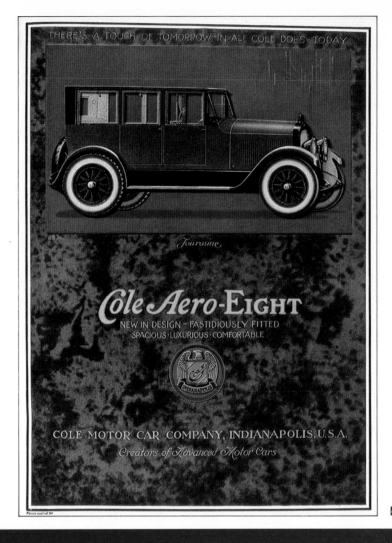

Tourosine

Cole Aero-EIGHT

NEW IN DESIGN ~ FASTIDIOUSLY FITTED
SPACIOUS · LUXURIOUS · COMFORTABLE

COLE MOTOR CAR COMPANY, INDIANAPOLIS, U.S.A.

Creators of Advanced Motor Cars

Introducing

THE LÉON RUBAY Voitures de Ville

Brougham Coupé Cabriolet
Sedan Berline

THE Voiture de Ville is a familiar sight in the capitals of Europe. It is the
approved conveyance for the man of affairs and for the woman of fashion. It is
designed for city streets, for dense traffic, for personal convenience, for economy
of operation. It is appropriate, distinctive, ideally suited to its purpose.

It is to meet the demand in American cities for an appropriate town conveyance
that The Rubay Company has designed and produced its Voitures de Ville along
European lines. The Léon Rubay is entirely French designed and built with the
exact craftsmanship for which that nation is noted. The best of American engineer-
ing skill has adapted the design to American standards.

The Rubay motor is the high speed type, with long stroke and small bore,
developing a wide range of power. It is extremely flexible, getting away and
picking up speed immediately. It develops only such power as is needed; from
ten or twelve horse for city use, to thirty-eight or forty for fast suburban
driving or climbing hills. The *four wheel brakes* add a tremendous factor of
safety in congested traffic.

*The Léon Rubay Voitures de Ville will be exhibited for the
first time at the New York Salon, December third to ninth.*

THE RUBAY COMPANY
CLEVELAND, OHIO.

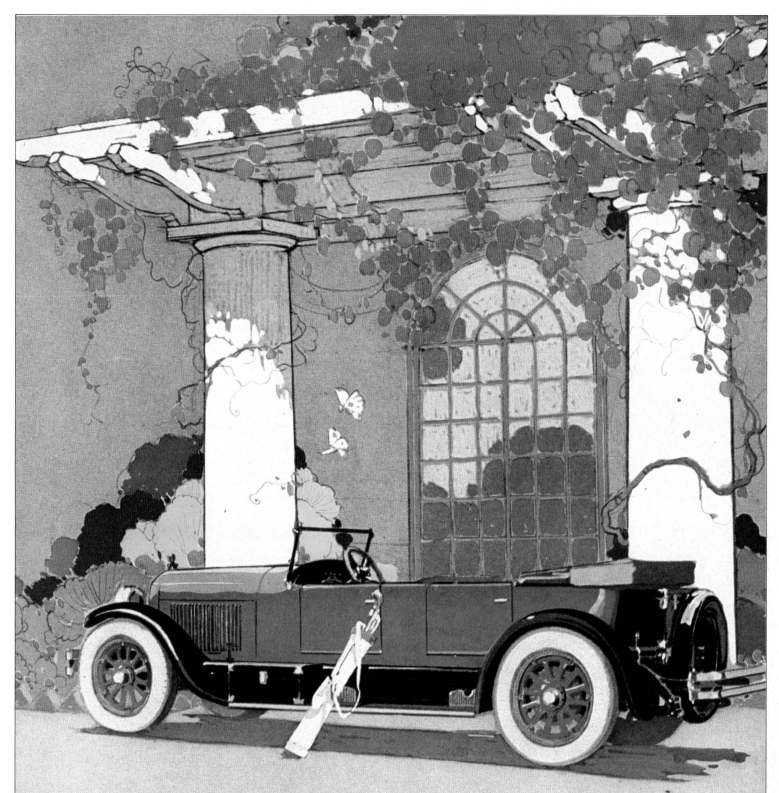

THE JORDAN BLUE BOY IN BLUE DEVIL BLUE

Built for those happy people who bought a Jordan Playboy
for their honeymoon, but now want a little more room for
the friends they take for an afternoon of golf.

The wheelbase has been lengthened for lowness. Cushions
hug the floor. The top fits like a swanky sport hat — and
all is slender — 'cept the tires — they are fat.

JORDAN

JORDAN MOTOR CAR COMPANY, Inc., Cleveland, Ohio

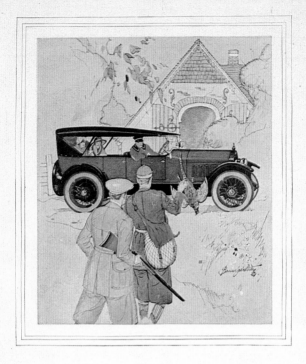

STUTZ

America's Pre-eminent Sports Cars

SIX-CYLINDER SERIES: $1995 to $2550
THE SPEEDWAY SERIES: $2450 to $3490
Exclusive of tax and freight

Stutz Motor Car Company of America, Inc.
Indianapolis, Indiana

Builders of the original and genuine Stutz cars

The Sign of the Genuine

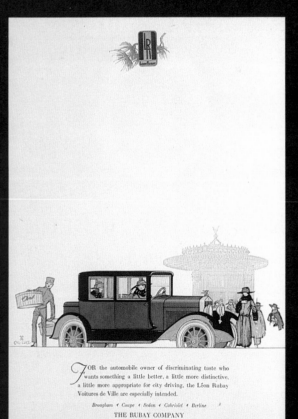

For the automobile owner of discriminating taste who wants something a little better, a little more distinctive, a little more appropriate for city driving, the Léon Rubay Voitures de Ville are especially intended.

Brougham • Coupe • Sedan • Cabriolet • Berline

THE RUBAY COMPANY
Cleveland

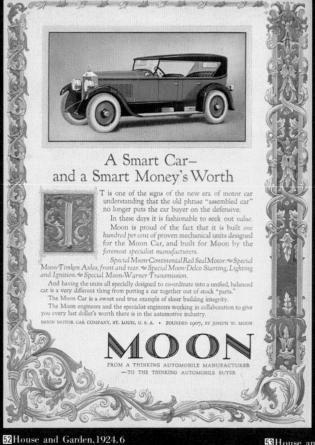

A Smart Car—
and a Smart Money's Worth

IT is one of the signs of the new era of motor car understanding that the old phrase "assembled car" no longer puts the car buyer on the defensive.

In these days it is fashionable to seek out *value*. Moon is proud of the fact that it is built *one hundred per cent of proven mechanical units* designed for the Moon Car, and built for Moon by the *foremost specialist manufacturers.*

Special Moon-Continental Red Seal Motor. ∾ Special Moon-Timken Axles, front and rear. ∾ Special Moon-Delco Starting, Lighting and Ignition. ∾ Special Moon-Warner Transmission.

And having the units all specially designed to co-ordinate into a unified, balanced car is a very different thing from putting a car together out of stock "parts."

The Moon Car is a sweet and true example of sheer building integrity.

The Moon engineers and the specialist engineers working in collaboration to give you every last dollar's worth there is in the automotive industry.

MOON MOTOR CAR COMPANY, ST. LOUIS, U. S. A. • FOUNDED 1907, BY JOSEPH W. MOON

MOON

FROM A THINKING AUTOMOBILE MANUFACTURER
—TO THE THINKING AUTOMOBILE BUYER

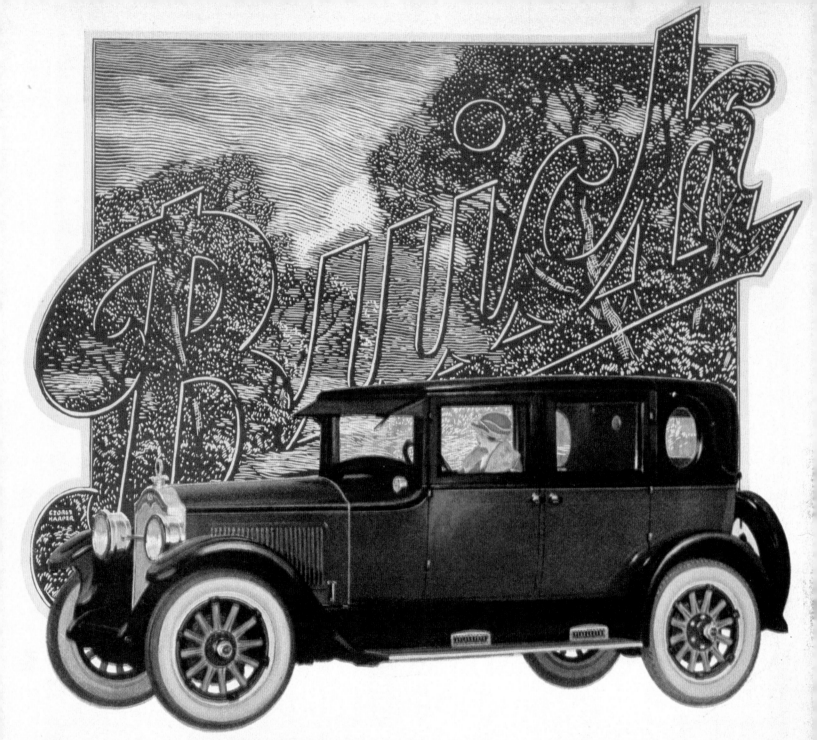

Smart, Fine-looking and very different—

The Brougham
Master Six
$2350

Price f. o. b. Buick Factories
Tax Extra

The Buick Brougham Sedan appeals to women who want the car they drive to possess distinctive personality. Four-wheel brakes, automatically-lubricated valve-in-head engine, low pressure tires and a one-piece ventilating windshield add as much to their pleasure, safety and comfort as the attractive appearance of this model adds to their pride of ownership.

WHEN BETTER AUTOMOBILES ARE BUILT, BUICK WILL BUILD THEM

BUICK MOTOR COMPANY, FLINT, MICHIGAN

Division of General Motors Corporation

Pioneer Builders of
Valve-in-Head Motor Cars

Branches in All Principal
Cities—Dealers Everywhere

Canadian Factories: McLAUGHLIN-BUICK, Oshawa, Ont.

Its ability to contribute to the daily life of her children, as well as to her own, is a feature the modern mother is quick to appreciate in the Ford Four-door Sedan.

It opens to her a precious participation in their busy affairs. With a Ford Closed Car she can share their good times and yet

hold to the necessary schedule of her day.

She finds in it the qualities she desires most, and at a price extremely low in comparison with its high value. She enjoys driving it herself; and the children look forward eagerly to their rides with mother at the wheel.

Not even a chilly all-day rain need upset the plans of the woman who has a Ford closed car at her disposal. Knowing it to be reliable and comfortable in all weathers, she goes out whenever inclination suggests or duty dictates.

The car is so easy to drive that it constantly suggests thoughtful services

to her friends. She can call for them without effort and share pleasantly their companionship.

All remark upon the graceful outward appearance of her car, its convenient and attractive interior, and its cosy comfort. And she prides herself upon having obtained so desirable a car for so low a price.

TUDOR SEDAN, $590. FORDOR SEDAN, $685. COUPE, $525.

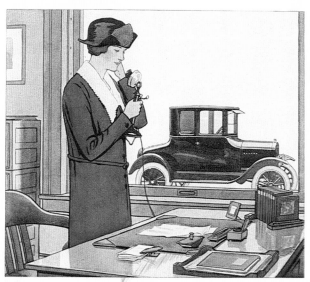

Her habit of measuring time in terms of dollars gives the woman in business keen insight into the true value of a Ford closed car for her personal use.

This car enables her to conserve minutes, to expedite her affairs, to widen the scope of her activities. Its low first cost, long life and inexpensive operation and upkeep convince her that it is a sound investment value.

And it is such a pleasant car to drive that it transforms the business call which might be an interruption into an enjoyable episode of her busy day.

TUDOR SEDAN, $590 FORDOR SEDAN, $685 COUPE, $525 (All prices f. o. b. Detroit)

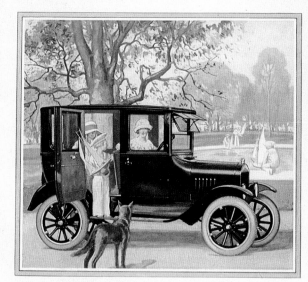

AS COOL in summer, as it is snug and weatherproof in winter, the Ford Closed Car has an unfailing appeal to women and children, who appreciate its many features of comfort.

Furnishings and equipment of the Sedan are of the highest order, including soft, durable cushions, revolving type window lifts, windshield visor, cowl ventilator, rugs, dome light, door locks, electric starting and lighting equipment.

And the Ford Closed Car costs so little to own and operate that mother and children can use it daily for every errand of business or pleasure.

TUDOR SEDAN, $590 FORDOR SEDAN, $685 COUPE, $525 (All prices f. o. b. Detroit)

Somewhere West of Laramie

SOMEWHERE west of Laramie there's a broncho-busting, steer-roping girl who knows what I'm talking about. She can tell what a sassy pony, that's a cross between greased lightning and the place where it hits, can do with eleven hundred pounds of steel and action when he's going high, wide and handsome.

The truth is—the Jordan Playboy was built for her.

JORDAN

JORDAN MOTOR CAR COMPANY, Inc., Cleveland, Ohio

"Somewhere West of Laramie"

Until the twenties, car advertisements for the most part consisted of pleasant color illustrations and very practical copy that focused almost exclusively on the car and its parts — the clutch, the wheel base, the transmission, the windshield, the tires. In the early twenties, however, the Jordan Motor Car Company started a novel ad campaign that ignored the buyer's needs and concentrated instead on a more abstract entity — the buyer's imagination. In Figure 58, the art is refreshing and original; the ad copy starts with the company's catch phrase, "Somewhere West of Laramie," and continues with "there's a broncho-busting, steer-roping girl . . . the Jordan Playboy was built for her." At the time, the Jordan ads were considered radical in their approach and were a frequent topic of conversation.

Perhaps more radical than the ads themselves is the fact that the art director, copywriter, and owner of the Jordan Motor Company were all the same person — Thomas Ned Jordan (1882–1958). Before starting his own motor company, Jordan had been an advertising company director and a professional publicity man.

Unfortunately for Jordan, his car received less attention than his ads, and his company collapsed in the Depression. Following this loss, Jordan worked as an advertising consultant and a columnist for car magazines.

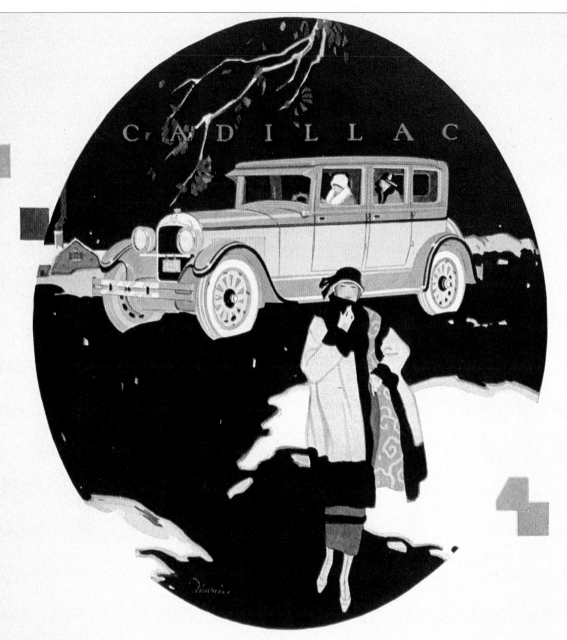

CADILLAC *Custom-Built* BODIES
~at prices consistent with wise investment

Cadillac invites you to give free rein to your individual preferences when you purchase a V-63 Cadillac with Custom Body by Fisher. ¶ From among the twenty-four master color harmonies, select the one which pleases you above all others. Choose the particular style of upholstery, in mohair or cloth, which appeals to you as being most beautiful. ¶ In this way, your Custom-Built Cadillac will faithfully reflect your own good taste. In this way, it will represent your personal ideal of beauty just as it represents the highest standard of dependable, vibrationless eight-cylinder performance.

CADILLAC MOTOR CAR COMPANY, DETROIT, MICHIGAN
Division of General Motors Corporation

STANDARD OF THE WORLD

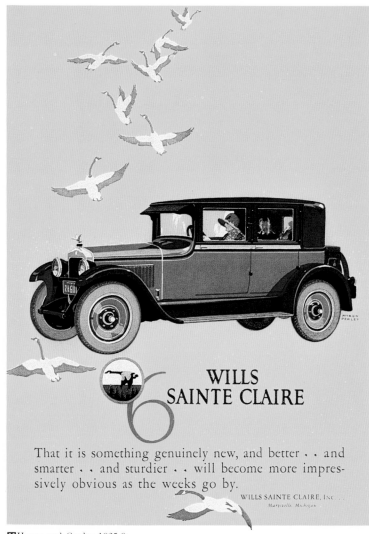

WILLS
SAINTE CLAIRE

That it is something genuinely new, and better · · and smarter · · and sturdier · · will become more impressively obvious as the weeks go by.

WILLS SAINTE CLAIRE, Inc.
Marysville, Michigan

60 House and Garden,1925.9

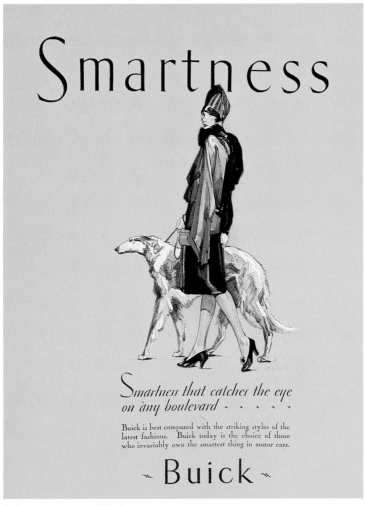

Smartness

Smartness that catches the eye on any boulevard · · · · ·

Buick is best compared with the striking styles of the latest fashions. Buick today is the choice of those who invariably own the smartest thing in motor cars.

~ Buick ~

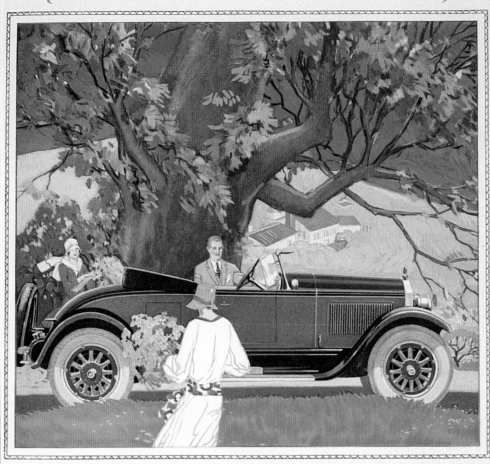

The Better Buick

People who ask for the finest in motor car design find it, at its most reasonable price, in the Better Buick.

..

62 House and Garden.1926.6

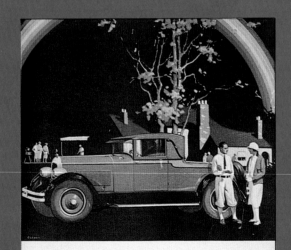

GLORIOUS DAYS are just ahead for lovers of the great outdoors. But what a dilemma confronts the ardent golfer who has just acquired this latest Paige! For he has learned from the wheel of his Cabriolet Roadster that motoring, in itself, is again one of the most delightful of outdoor sports . . . that there is something newer and finer in motor car performance . . . and whether to play or whether to drive . . . there is a problem of problems! When you go for your first drive in "The Most Beautiful Car in America" don't hesitate to take the feminine members of your household with you. For this year—a Paige costs nearly a thousand dollars less.

PAIGE
The MOST BEAUTIFUL CAR IN AMERICA

63 House and Garden.1926.5

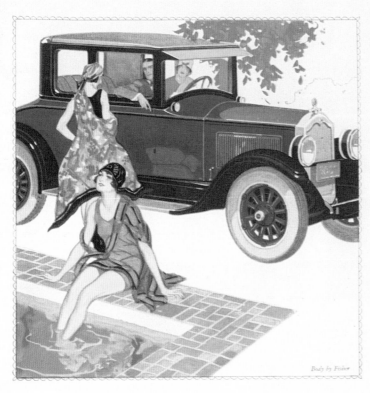

THE familiar phrase *"as good as Buick"* suggests that you see and drive the car that others use as the Standard of Comparison before you spend your money.

"WHEN BETTER AUTOMOBILES ARE BUILT··· BUICK WILL BUILD THEM"

The Better Buick

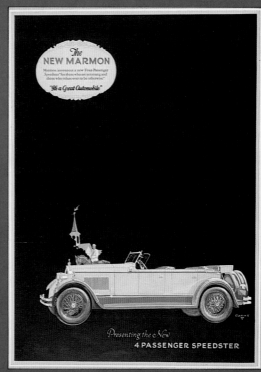

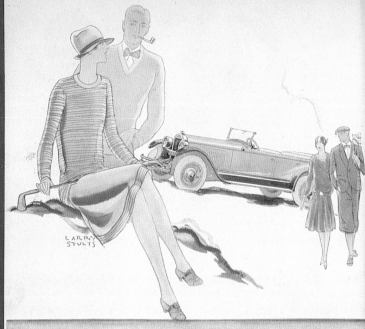

66 House and Garden, 1926.10 67 House and Garden, 1927.8

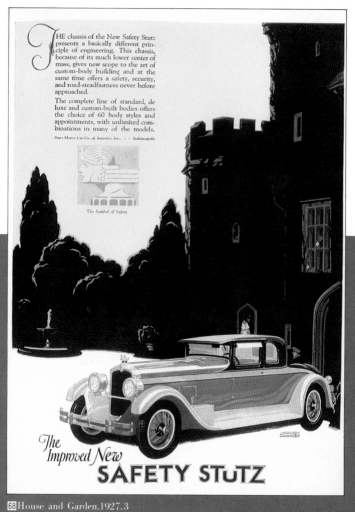

68 House and Garden.1927.3

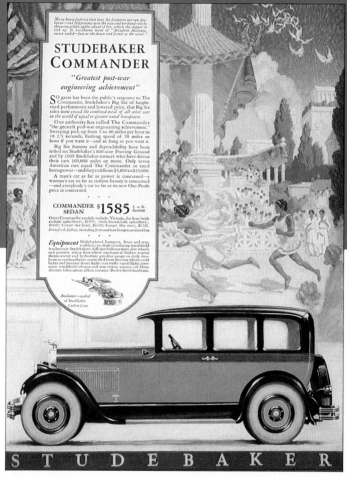

69 House and Garden.1927.6

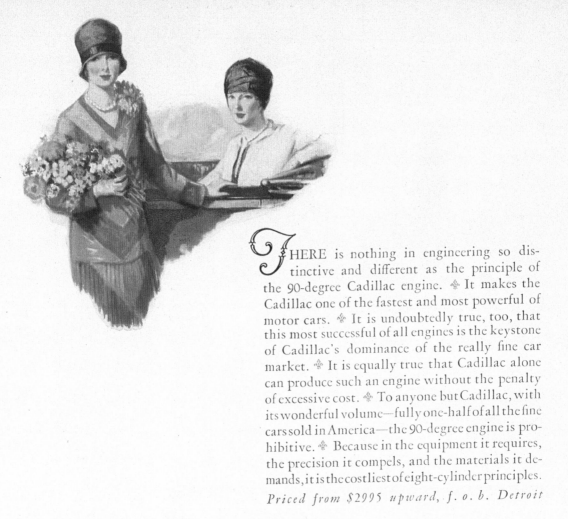

*T*HERE is nothing in engineering so distinctive and different as the principle of the 90-degree Cadillac engine. ❖ It makes the Cadillac one of the fastest and most powerful of motor cars. ❖ It is undoubtedly true, too, that this most successful of all engines is the keystone of Cadillac's dominance of the really fine car market. ❖ It is equally true that Cadillac alone can produce such an engine without the penalty of excessive cost. ❖ To anyone but Cadillac, with its wonderful volume—fully one-half of all the fine cars sold in America—the 90-degree engine is prohibitive. ❖ Because in the equipment it requires, the precision it compels, and the materials it demands, it is the costliest of eight-cylinder principles.

Priced from $2995 upward, f. o. b. Detroit

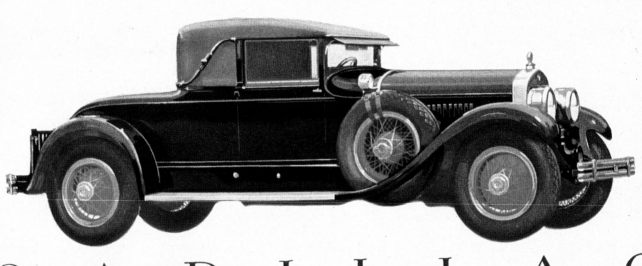

C A D I L L A C

DIVISION OF GENERAL MOTORS CORPORATION

Cadillac and La Salle Motor Cars

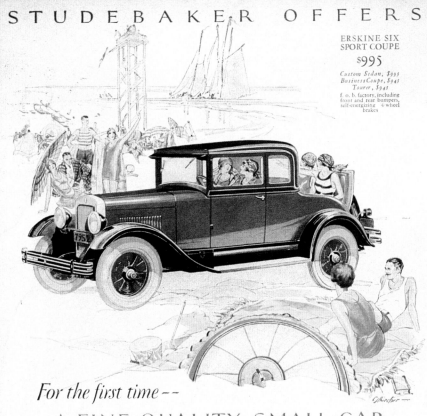

STUDEBAKER OFFERS

ERSKINE SIX
SPORT COUPE
$995

Custom Sedan, $995
Business Coupe, $945
Tourer, $945
f. o. b. factory, including
front and rear bumpers,
self-energizing 4-wheel
brakes

For the first time --

A FINE QUALITY SMALL CAR

FINE thin watches have displaced the bulky ones. Compact comfortable homes have supplanted mid-Victorian mansions. Bulk is no gauge of worth with people of good taste.

And now comes the fine quality small car! The Erskine Six has big car smartness and sophistication—big car luxury and comfort. But in small car fashion it is agile and deft and most economical to maintain.

There's a silken sixty-mile gait tucked under its bonnet —ready for use in a flash when you want it. It volleys ahead with an acceleration of 5 to 25 miles in 8¼ seconds. Hills hold no difficulty for this rugged performer—it climbs a stiff 11% grade in high.

The Erskine Six turns in an 18-foot radius, parks in a minimum of inches. It is exceptionally easy on gas, oil and tires. All but 19 inches of its entire wheelbase is made up of cradling springs—one factor which contributes to its remarkable riding ease.

But there's no use talking here when the Erskine Six has so much to tell you *on the road.* That's where your liking for this Little Aristocrat will develop and ripen into a lasting companionship.

Equipment, Erskine Six Sport Coupe: Self-energizing 4-wheel brakes; bumpers, front and rear; motometer; full-size balloon tires; two-beam headlights; oil filter; rear traffic signal light; cowl ventilator; one-piece windshield; thief-proof coincidental lock to ignition and steering; automatic windshield cleaner; rear vision mirror; hydrostatic gasoline gauge on dash; instrument board compartments; broadcloth upholstering with broadlace trim.

ERSKINE SIX

(THE LITTLE ARISTOCRAT)

71 House and Garden,1927.9

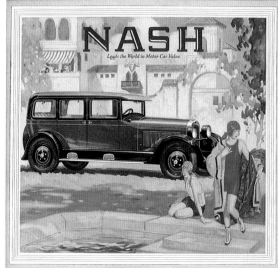

The Special Sedan on the Special Six Chassis

The Smartest Thing in Motor Car Design
—the French-Type Back

There is much more than good taste involved when people choose this *Special* Sedan in preference to some other car of older design.

It is strictly sound business to select a car styled to-date instead of out-of-date.

This reasoning applies with equal force to engineering points—for example, the older style in motor design employs only 3 or 4 crankshaft bearings.

But the *ultra*-modern motor has 7 great main bearings—because 7 can do what 3 or 4 cannot —in bringing you performance of far greater power-smoothness and power-quietness.

So in the *Special* Sedan with its subtly graceful French-type roof and rear contour you get the latest in body style, the latest in engineering, and the latest in fittings and appointments too.

The upholstery is gray Chase Velmo Mohair Velvet, heavily tufted. The steering wheel is of real walnut and the inside window mouldings, door panels, instrument board, and crowned panel above, are of walnut finish.

Included in the surprisingly low price are such notable features of equipment as Gabriel snubbers at front, 4-wheel brakes of special Nash design, and 5 disc wheels.

72 House and Garden,1927.5

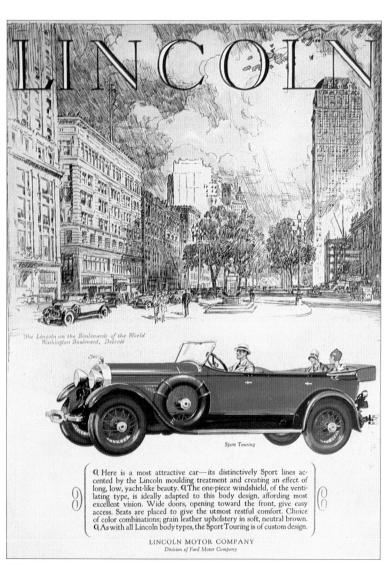

The Lincoln on the Boulevards of the World
Washington Boulevard, Detroit

Sport Touring

¶ Here is a most attractive car—its distinctively Sport lines accented by the Lincoln moulding treatment and creating an effect of long, low, yacht-like beauty. ¶ The one-piece windshield, of the ventilating type, is ideally adapted to this body design, affording most excellent vision. Wide doors, opening toward the front, give easy access. Seats are placed to give the utmost restful comfort. Choice of color combinations; grain leather upholstery in soft, neutral brown. ¶ As with all Lincoln body types, the Sport Touring is of custom design.

LINCOLN MOTOR COMPANY
Division of Ford Motor Company

73 House and Garden, 1927.7

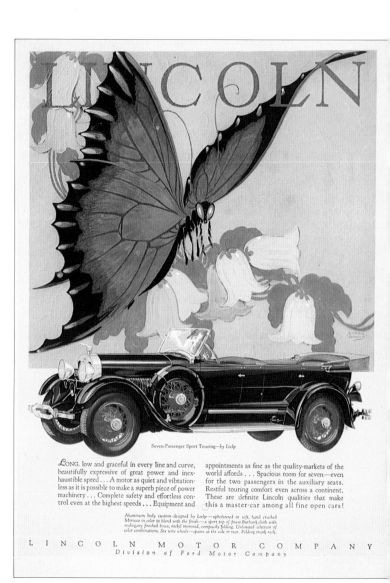

Seven-Passenger Sport Touring—by Locke

LONG, low and graceful in every line and curve, beautifully expressive of great power and inexhaustible speed ... A motor as quiet and vibrationless as it is possible to make a superb piece of power machinery ... Complete safety and effortless control even at the highest speeds ... Equipment and appointments as fine as the quality-markets of the world affords ... Spacious room for seven—even for the two passengers in the auxiliary seats. Restful touring comfort even across a continent. These are definite Lincoln qualities that make this a master-car among all fine open cars!

Aluminum body custom-designed by Locke—upholstered in soft, hand crushed Morocco in color to blend with the finish—a sport top of finest Burbank cloth with mahogany finished bows, nickel trimmed, compactly folding. Unlimited selection of color combinations. Six wire wheels—spares at the side or rear. Folding trunk rack.

LINCOLN MOTOR COMPANY
Division of Ford Motor Company

74 House and Garden, 1928.7

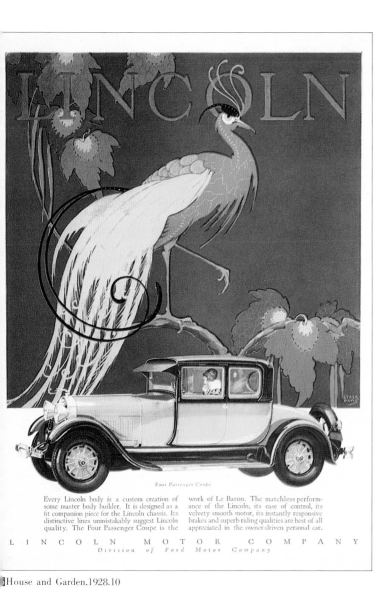

Four Passenger Coupe

Every Lincoln body is a custom creation of some master body builder. It is designed as a fit companion piece for the Lincoln chassis. Its distinctive lines unmistakably suggest Lincoln quality. The Four Passenger Coupe is the work of Le Baron. The matchless performance of the Lincoln, its ease of control, its velvety smooth motor, its instantly responsive brakes and superb riding qualities are best of all appreciated in the owner-driven personal car.

LINCOLN MOTOR COMPANY
Division of Ford Motor Company

House and Garden,1928.10

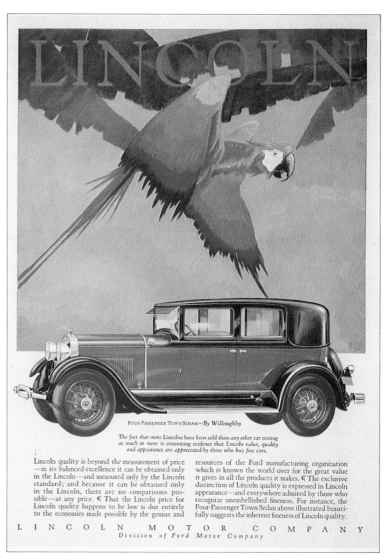

FOUR-PASSENGER TOWN SEDAN — By Willoughby

The fact that more Lincolns have been sold than any other car costing as much or more is convincing evidence that Lincoln value, quality and appearance are appreciated by those who buy fine cars.

Lincoln quality is beyond the measurement of price —in its balanced excellence it can be obtained only in the Lincoln—and measured only by the Lincoln standard; and because it can be obtained only in the Lincoln, there are no comparisons possible—at any price. ¶ That the Lincoln price for Lincoln quality happens to be low is due entirely to the economies made possible by the genius and resources of the Ford manufacturing organization which is known the world over for the great value it gives in all the products it makes. ¶ The exclusive distinction of Lincoln quality is expressed in Lincoln appearance—and everywhere admired by those who recognize unembellished fineness. For instance, the Four-Passenger Town Sedan above illustrated beautifully suggests the inherent fineness of Lincoln quality.

LINCOLN MOTOR COMPANY
Division of Ford Motor Company

The Choice
of Cultivated Taste

DODGE BROTHERS
Senior Line

A CAR whose beauty, appointments and performance have placed it at once in the company of the elite.

And yet as rugged to resist wear as cliffs resist the sea.

It was inevitable that this car would come. It was logical that rich experience, vast and modern plant facilities, and farsighted, progressive management should produce it.

Today—wherever quality cars are owned— you will find a growing enthusiasm for this distinguished Six by Dodge Brothers.

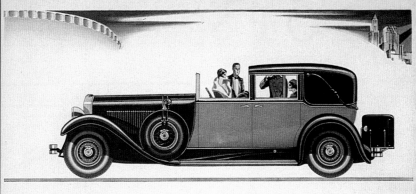

Expressing a new note in motor car personality

THE FLARE for individualism in motor car modes naturally draws critical attention to those De Luxe creations by Stearns-Knight which have sounded such a refreshingly new note in automotive artistry this year.

There are many cars, of course, that may be appointed and finished to one's personal preferences, but the De Luxe Stearns-Knight is the only American-made car providing unlimited facilities for individual expression on a chassis possessing the exclusive combination of the straight eight double sleeve-valve Knight engine superbly balanced by the silent worm drive axle.

The De Luxe Stearns-Knight holds such a marked margin over contemporaneous cars in magnificent power, surpassing quietness, effortless control and alluring comfort, that the standards this car creates are not to be comprehended until the car is actually seen and driven "in person."

STEARNS-KNIGHT SALES CORPORATION, CLEVELAND

JOHN N. WILLYS, *Chairman of the Board* H. J. LEONARD, *President*

Stearns-Knight
Motor Cars of Quality

No Other Word Describes It!

IT'S *new*. And long. And low. It somehow catches your eye. Style? To be sure. Smartness? Of course. But there's something else in addition.

* * *

You can't express it. Neither can we. But we're certain that you'll like it.

* * *

Same when you're threading through traffic. Or skimming over the Post Road with the accelerator against the floor. Power—smoothness—silence—snap. All those, yes. But there's that feeling again—an indefinable something else.

* * *

You never felt it in a car before. For this is a new interpretation of American needs in a motor car.

* * *

American principles of design for every condition of American use. American traditions of motor car beauty. American standards of

staunchness and strength. All combined in a single car.

* * *

All-American! That's the word. And no other word describes it.

* * *

Instinctively your eyes detect the mastery of America's master body builders—and seek the emblem "Body by Fisher."

* * *

Immediately you sense a new road mastery. That's not merely the big new motor. But the longer, stronger, lower chassis—the new transmission clutch and wheels—the new developments in balancing and spring design—all combined to deliver a new type of performance.

* * *

Dependable? Study the over-dimensions. Luxury? Observe the numerous new luxury features.

* * *

Value? Look at the new low prices. A success? Ask anyone!

2-Door Sedan, $1045; London Coupe, $1045; Sport Roadster, $1075; Cabriolet, $1145; 4-Door Sedan, $1115; London Sedan, $1265. All prices at factory.

OAKLAND MOTOR CAR COMPANY, PONTIAC, MICHIGAN

OAKLAND
ALL-AMERICAN SIX
PRODUCT OF GENERAL MOTORS

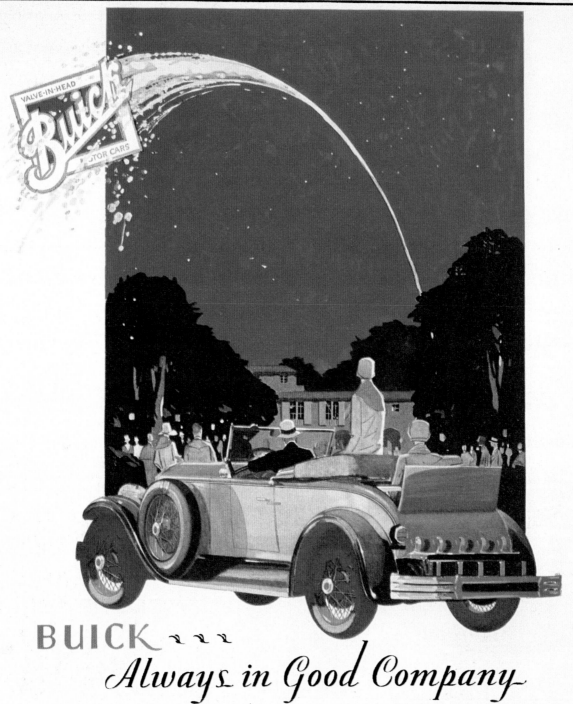

BUICK ...
Always in Good Company

That group of men you saw today in a Buick car will "check in" tonight at the most exclusive club in town And that smartly-gowned woman who parked her Buick so deftly will grace the most important social event of the season. Men and women of fashion choose Buick, not because it sells for a thousand dollars less than other fine cars, but because it is as modish, luxurious and capable as they could wish a car to be. You, too, will find Buick a pattern of all that is fine and beautiful in a motor car.

Simon Werner painted the portrait alongside in the same setting as the one shown below, which he executed ten years earlier. Both people and Pierce-Arrows of the former day share with today's group the distinguished quality of the patrician.

The finest traditions of Pierce-Arrow

Are Reborn in the New Straight Eight

For many years our best families have owned Pierce-Arrows as a matter of well-bred habit. But this generation demands more than character in a motor car—more even than beauty and fine tradition. And the new Straight Eight by Pierce-Arrow provides lavishly against the new demands.

Beneath its distinguished hood, for example, there is a volume of power such as few cars know—and a corresponding fleetness.

There is a slender grace, too, about this new creation,

which is Pierce-Arrow at its very loveliest—a refreshing departure from the "dowager" type of fine car.

Pierce-Arrow, in short, has brought forth a new automobile out of its finest tradition, its richest experience. And that it arrives at the psychological moment is evidenced by the greatest waiting demand in Pierce-Arrow history.

Prices from $2775 to $8200, at Buffalo. In the purchase of a car from income, the average allowance usually more than covers the initial Pierce-Arrow payment.

PIERCE-ARROW

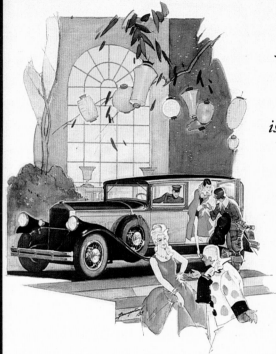

Wrought by Hand

is Pierce-Arrow Fineness!

Portraits of Garden Parties and Pierce-Arrows . . . yesterday's and today's. The one, painted fifteen years ago, resembles the 1929 version in every particular of fineness and distinction . . . in the unchanging quality that is Pierce-Arrow.

The simplest work of art reminds us that the finest things of this world are wrought by hand—that machinery, however modernly miraculous, must ever lack the genius of the human touch.

Pierce-Arrow is a case in point!

It would be so much easier and so much less expensive, for example, to substitute the machine product for much Pierce-Arrow handwork. But the result could never be Pierce-Arrow.

Only human hands—trained to high traditions—could be responsible for the exquisite coachwork of Pierce-Arrow fame. And nothing less could conceivably create the beautiful Pierce-Arrow interiors—or the fine precisions that are present in all Pierce-Arrow mechanism.

To repeat: *The finest things of this world are wrought by hand!*

Pierce-Arrow prices are appropriate: From $2775 to $8200, at Buffalo. In the purchase of a car from income, the average allowance usually more than covers the initial Pierce-Arrow payment.

PIERCE-ARROW

LUXURIOUS TRANSPORTATION

That Packard is the greatest name among motor cars is far from being either accidental or mere good fortune. That no other car possesses the Packard reputation is but the natural result of Packard's unusual history—its thirty-year background of experience that cannot be duplicated and that money cannot buy.

Packard reputation has a very practical meaning to Packard owners. It assures not only advanced engineering, the finest of materials, and supreme craftsmanship, but also unusual service and an exceptionally low depreciation cost.

It is a fact well worth considering that two out of three of those who buy Packard cars give up other makes to do so.

These thousands are for the first time enjoying truly luxurious transportation of a sort they have never known before. Their satisfaction results not only from superior performance and unusual comfort and beauty but also from the constant realization of the fact that their cars bear the crest of Packard.

PACKARD

ASK THE MAN
WHO OWNS
ONE

The slaves of the Caliph's household gently carried the women of his harem in luxurious palanquins

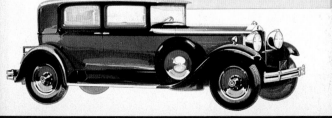

DISTINCTION...

The introduction by Franklin of the first airplane-type engine in a motor car—an engine which in tests has flown an airplane—is heralded as a great forward step in the automobile's march of progress. A vision of the future—the turning point of a new era.

Even more important and dramatic is this engine's tremendous power-ability. Delivering the greatest power for cylinder capacity of all automotive power plants, it brings air-cooling engineering into undisputed leadership. It sweeps aside all previous conceptions of motor-car performance. Sixty, seventy, eighty miles an hour are quickly, quietly and comfortably reached without the slightest engine exertion.

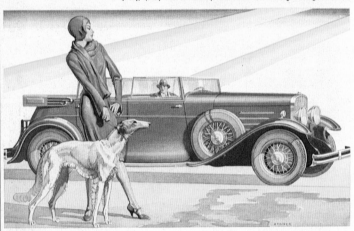

Now riding is gliding. You get a new thrill every time the Franklin does things you thought impossible before. Last year Franklin gained the distinction of holding all major road records. This year many of these same records have been sensationally re-broken by the new Franklin.

Distinguished for its airplane performance, the new Franklin also enjoys nation-wide distinction for its authoritative appearance. Darting-arrow horizontal louvres—modishly fashioned embossed paneling—low hung doors concealing the running boards—gracefully arched hood front, ribbon-wide, with highlighted vertical shutters—the whole exterior ensemble is modern, smart, fleet-looking . . . When you see the car—when you are thrilled by the performance of its airplane-type engine, you will enthusiastically award Franklin highest motor car honors for 1930. Franklin Automobile Company, Syracuse, New York.

AIR-COOLED

FRANKLIN

84 House and Garden,1929.4

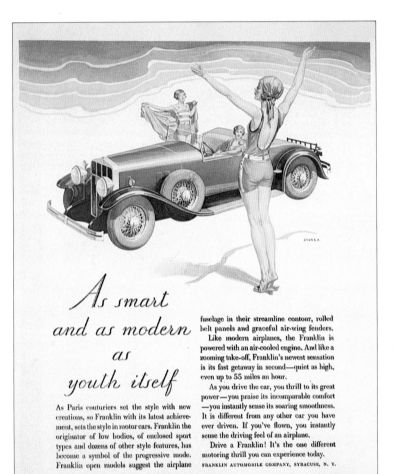

As smart and as modern as youth itself

As Paris couturiers set the style with new creations, so Franklin with its latest achievement, sets the style in motor cars. Franklin the originator of low bodies, of enclosed sport types and dozens of other style features, has become a symbol of the progressive mode. Franklin open models suggest the airplane fuselage in their streamline contour, rolled belt panels and graceful air-wing fenders.

Like modern airplanes, the Franklin is powered with an air-cooled engine. And like a zooming take-off, Franklin's newest sensation is its fast getaway in second—quiet as high, even up to 55 miles an hour.

As you drive the car, you thrill to its great power—you praise its incomparable comfort—you instantly sense its soaring smoothness. It is different from any other car you have ever driven. If you've flown, you instantly sense the driving feel of an airplane.

Drive a Franklin! It's the one different motoring thrill you can experience today.

FRANKLIN AUTOMOBILE COMPANY, SYRACUSE, N. Y.

The new Franklin prices begin at $2160 F.O.B. Factory

FRANKLIN

85 House and Garden,1929.6

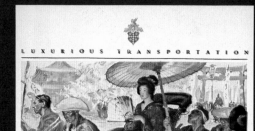

OPENING DAY AT THE RACES...BELMONT PARK

FLEET HOOFS, pounding out the cadence of the sport of kings ... a gracious sweep of lawn, gorgeous with gay folk. High spirits—high festival—when beautiful Belmont opens its season. And a glance at the motorpark discovers how high the favor runs for the great straight eights and sixes by Studebaker, Builder of Champions! Holding undisputed *every* official stock car record for speed and endurance, these spirited motor cars show their mettle in every liquid line and curve. Low-swung and lithe, these smart new Studebakers are champions in looks as in fact ... and in manners. At their One-Profit prices, no wonder Studebaker now sells more eight-cylinder cars than any other manufacturer in the world! Illustrated is The President Eight Convertible Cabriolet for Four; six wire wheels, standard equipment.

Studebaker
BUILDER OF CHAMPIONS

LUXURIOUS TRANSPORTATION

AMERICA'S FIRST FRONT-WHEEL-DRI[VE] MOTOR CAR

It was a notable group of men who had met for dinner . . . representative men i[n]

several fields of achievement . . . art and letters, commerce and finance . . . an[d]

conversation eventually centered upon motor cars . . . And it was the common c[omplaint]

that the automobiles they owned, while rated fine and dependable, fell somewha[t short]

of the consummate.

Body silence, riding comfort, flowing motion, all the other attributes so glowingly [prom-]

ised had never been realized to the full . . . More than all else, these cars lack[ed that]

individuality of design which sets their homes and their other personal possessions [apart.]

And these men of sound judgment and good taste finally got to wondering, ou[t loud,]

if something couldn't be done about it. Ideas were exchanged, and suggestions [made.]

And because they have the money and the will to have just what they want, [when such]

wants are humanly attainable, they reached this decision:

"Let's see if these conjectures of ours are practical. If they are, why not finan[ce and]

build such a car? Maybe something good will come out of it."

So engineers were called in, blueprints were made, ideas were translated into [steel.]

And this car, today, after two years of unhurried development, rides the bouleva[rds.]

One of its twelve sponsors has given to it his name . . . Ruxton. The engine that [drives]

it is a straight-eight, of course. The body is handcrafted by Budd . . . Joseph Urban, [who]

yet supreme in the sphere of stage decor, has created its colorings . . . Schumac[her]

loomed its exclusive fabrics.

And in this starkly, smartly individual car, the decided advantages of the front [wheel]

drive may be enjoyed . . . for the first time in history of American automobile de[sign.]

A CAR SO LOW THAT YOU CAN LOOK OVER [IT]
A CAR SO SMART NONE CAN OVERLOOK I[T]

THE
RUXTON HANSOM
FOR TOWN
TRAVEL

BODY BY BUDD
COLORINGS BY URBAN
FABRICS BY SCHUMACHER

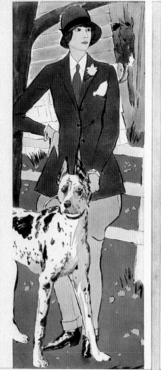

AMONG THE DISTINGUISHED DRIVERS
OF THE HUPMOBILE CENTURY EIGHT

Mrs. Markoe Robertson
[NÉE CORDELIA D. BIDDLE]

She doesn't like trains, and always prefers to
motor. Gervais makes her clothes including the
smartest green leather motoring coat to be seen
this side of Paris. Usually she drives herself...and
then it's a HUPMOBILE, her personal car. Once she
drove from her estate, Guinea Hollow Farm, at
Old Westbury to New York in forty minutes. To the
theatre she rides in a Rolls, a Minerva, or a Renault.
And drives it *mentally* all the way, even though
the most expert of chauffeurs is at the wheel. She
likes her HUPMOBILE because it's as smart as her
flat little wrist watch by Cartier, fleet as her fastest
hunter, trim as her riding habits by Huntsman.

89 House and Garden.1929.3

She can't quite decide which is the more
exciting (bystanders say it's fifty-fifty with
her verve)... jumping horses or driving a
powerful car. So she does both...with a
flair. Rides to hounds at Lake Forest and
flits to France for the hunting at Pau.
Drives her HUPMOBILE wherever the road
leads. Owns Au Paradis, a clever shop de-
voted to modern decoration. And owns an
absolute gift for amateur theatricals. Col-
lects modern jewelry and her pieces by Paul
Brandt and Fouquet of Paris are something
to write articles about. Vionnet and Nicole
Groult make her clothes. Agnes creates her
hats, and smart as they are it's sinful to hide
her white hair. Carol & Roberts of London
make her riding habits. She drives a car as
she hunts or works or plays... and that's
hard. So it takes a HUPMOBILE. She likes
it because it's fast and spirited as her best
hunter, masculine in its rugged strength,
feminine in its suave, silky, luxurious ease.

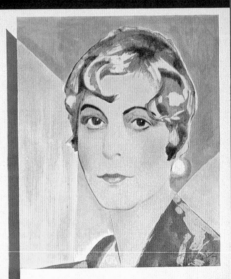

AMONG THE DISTINGUISHED DRIVERS
OF THE NEW CENTURY HUPMOBILE

Mrs. Howard Linn
[NÉE LUCY BLAIR]

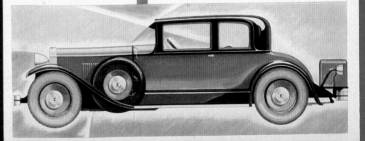

90 House and Garden.1929.5

The new
Overland
the achiev
in a high
WILLYS
WILLYS-OV

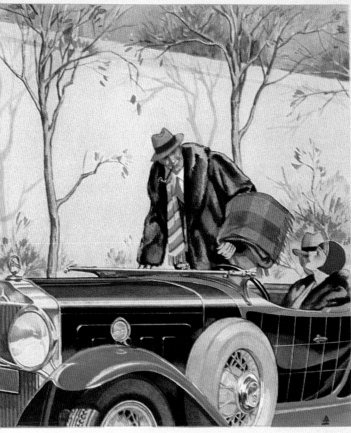

ITS BEAUTY EXPRESSES
SUPREME MASTERY OF MODERN DESIGN

ht Great Six is the most distinctively beautiful motor car that Willys-
ated. Line, color and finish combine in a rich ensemble that marks
w ideals in design. The individuality of the new Great Six reveals itself
beauty, luxury and performance.

ND, INC. · TOLEDO, OHIO
S CO., LTD. · TORONTO, CANADA

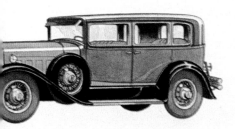

Willys-Knight

GREAT SIX

Sedan, Roadster, Coupe,
5-passenger Coupe — each,
$1895

*Six wire wheels and trunk rack
standard equipment. Prices f.o.b.
Toledo, Ohio, and specifications
subject to change without notice*

This
Fine Courtesy
Pierce-Arrow Commands!

IN almost any motoring circumstance, Pierce-
Arrow commands a courtesy seemingly reserved
for no other automobile, however fine. Attention
that is extra alert, a certain gracious right-of-way
. . . even a trifle more humaness on the part of
traffic officers . . . are among the unvarying experi-
ences of Pierce-Arrow owners.

All of which is important only as it denotes a
universal and never-failing appreciation of that
which is genuinely fine. On this single premise is
moulded every Pierce-Arrow tradition. Thus, while
the new Straight Eight is an ultra-modern expres-
sion of America's finest motor car . . . slender, low-
swung, luxurious, powerful . . . crisp and modish as
something fresh from Paris . . . it is, beyond all,
a Pierce-Arrow.

*Twenty years ago, Adolph Treidler did the illustration along-
side. It was not unusual for a Pierce-Arrow advertisement, but
as a portrayal of a distinguished figure of that day. And, save
for changing fashion, the same subject serves equal purpose today
—with the aid of Pierce-Arrow and Mrs. Treidler, as above.*

Pierce-Arrow prices are from $2775 to $8200, at Buffalo.
In the purchase of a car from income, the average allowance
usually more than covers the initial Pierce-Arrow payment.

PIERCE-ARROW

for Economical Transportation

CHEVROLET

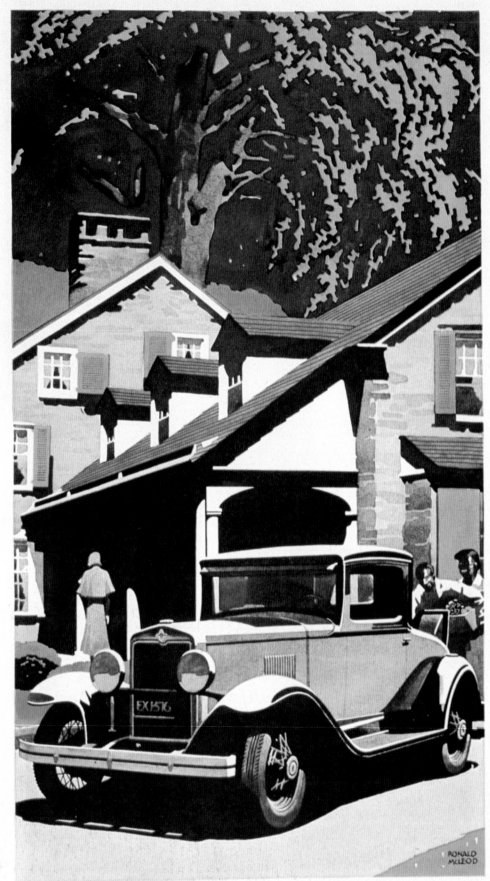

Illustrated above is the Sport Coupe, priced $655 at the Flint factory

Enjoying Exceptional Vogue

There is something significant in the persistently growing vogue which the Chevrolet Six is enjoying among those of acknowledged taste and discernment. For such motorists demand more than simple economy in the car they select for personal use.

It must have the qualities of smoothness and restfulness to which their costlier cars have accustomed them. It must be smartly styled. It must be tastefully appointed.

And to insist on these fundamentals of luxurious motoring in a low-priced car is—inevitably—to choose a Chevrolet Six. Because Chevrolet alone in the low-price field combines the inherent superiorities of six-cylinder engine design with the advantages in coachcraft everywhere associated with Body by Fisher.

Open Models, $495 and $555. Closed Models, $565 to $725, f. o. b. factory Flint, Michigan

CHEVROLET MOTOR COMPANY
DETROIT, MICH.
Division of General Motors Corporation

IT'S WISE TO CHOOSE A SIX

MARMON

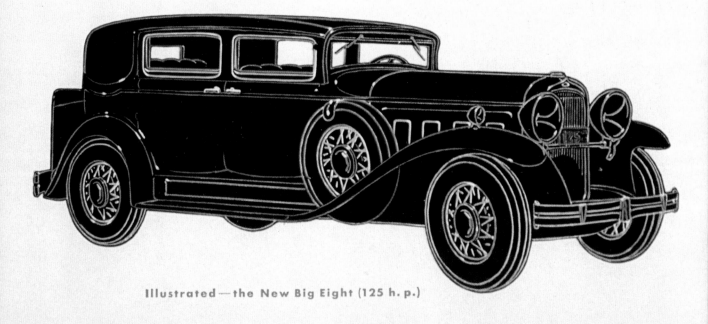

For more than twenty-seven years Marmon has meant the truly distinc-
tive, the luxurious, the fine thing well done + + + **Today Marmon means all that and**
more with an entirely new line **of cars**—each a straight-eight, **each**
abundant in advanced engineering thought—each with that charm and un-
usualness which is so inseparably Marmon + + + New easy riding qualities and
super comfort dimensions + + + With these cars Marmon covers the entire
range of fine cars—the Big Eight—the "Eight-79"—the "Eight-69" and the
Marmon-Roosevelt—a car for every possible motor car need.

Illustrated—the New Big Eight (125 h. p.)

Marmon Motor Car Company, Indianapolis

Many cars produced between the twenties and thirties had very distinctive body types, unlike anything seen on the roads today. A few of these automobiles, for example, had a rumble seat, which was a folding supplementary seat for two attached to the car where the trunk is now located (see Figure 80). Passengers in the rumble seat (also called a "mother-in-law seat") rode in the open air and often arrived at their destinations windblown or drenched by rain.

A more exclusive version of the rumble seat was the Sedan de Ville, which was designed with the high-society motorist in mind (see Figure 95). Vaguely resembling a horse-drawn carriage, this car separated the driver from his enclosed passengers, and conversation between the two took place via a speaking tube — remnants of the days when the upper class neither spoke directly to the servants nor sat near them.

LINCOLN

The fully
collapsible
Cabriolet by
Holbrook.

LINCOLN MOTOR COMPANY
Division of
Ford Motor Company

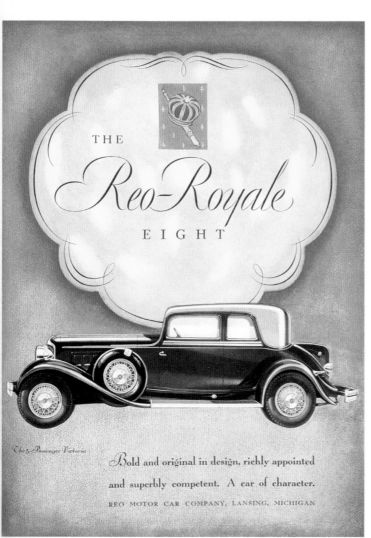

THE

Reo-Royale

EIGHT

The 5-Passenger Victoria

Bold and original in design, richly appointed
and superbly competent. A car of character.

REO MOTOR CAR COMPANY, LANSING, MICHIGAN

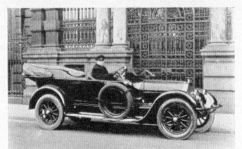

MR STEPHEN BAKER, PROMINENT NEW YORK BANKER, *purchased the Pierce-Arrow pictured above in 1917. It is still one of the most important cars in his service.*

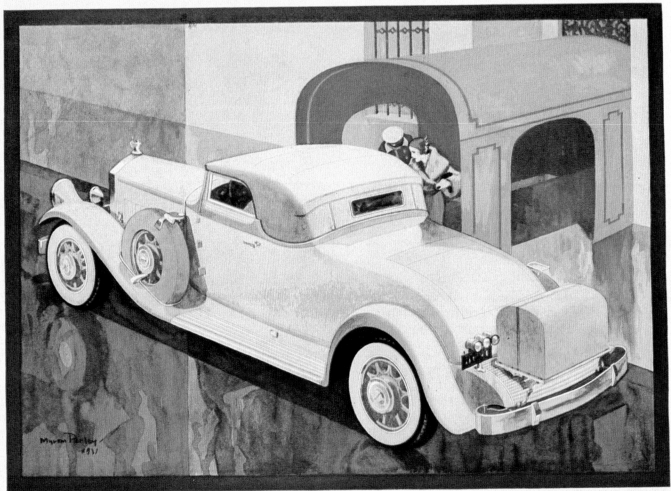

Convertible Coupe of the Salon Group . . $4275 at Buffalo

Against a background of tradition and quality singular to Pierce-Arrow alone among fine cars, Pierce-Arrow presents today's concept of all that can create distinguished motoring . . . Styled and engineered for those influential groups who have approved Pierce-Arrow for 30 years, and whose preference stamps anything as the finest of its kind, the new Pierce-Arrows are done with characteristic finish and finesse . . . Pierce-Arrow confidently looks to these, the finest cars it has ever produced . . . the very pinnacle of fine car values . . . to extend still further the high position with which it has been honored by two generations.

Twenty-nine New Models . . *with Free Wheeling* . . from $2685 to $6400 at Buffalo

PIERCE-ARROW

(Custom-built Models up to $10,000)

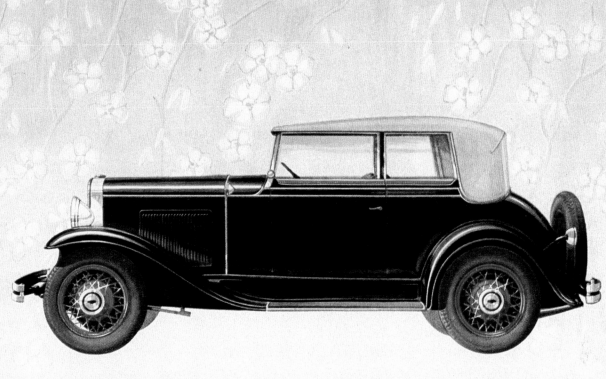

In creating a fully convertible Landau Phaeton for the Chevrolet Six, Fisher adds another brilliant triumph to its long record of achievement in coachcraft.

Heretofore, this distinctive body type has been offered solely in the costly custom field. Today, in a spirited interpretation, solidly constructed and handsomely finished, it is available at Chevrolet's low price.

The Landau Phaeton is racy in its design, with bold moulding treatments, wide doors, and rakish roof line. The ingenious top mechanism is solid and rattle-proof, but lowers easily and compactly. Upholstery in leather, deep, restful cushions, side arm rests, and recessed ash trays are among its fine-car features. Thus Fisher's skill in design and craftsmanship plus the resources of Chevrolet and General Motors brings a model long popular for custom use within the reach of every car buyer.

Fisher is proud to have had a part in this achievement and to join with Chevrolet in offering for the first time at modest cost a car of such pronounced charm, all-season utility, and high value.

FISHER BODY CORPORATION · DETROIT, MICHIGAN
Division of General Motors

Lowering easily, the top fits neatly into a compact boot. Windows lower into the doors, windshield folds forward.

LOOK TO THE BODY!

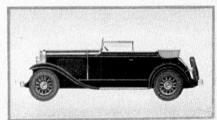

With top lowered and windows raised, this car combines the freedom of an open car with protection against drafts.

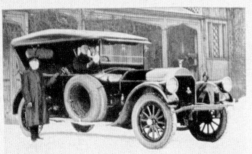

HONORABLE HORACE WHITE OF NEW YORK
is the owner of the Pierce-Arrow in the photograph
. . . a car which has been in the constant service
of the former Governor and his family since 1917

PIERCE
ARROW

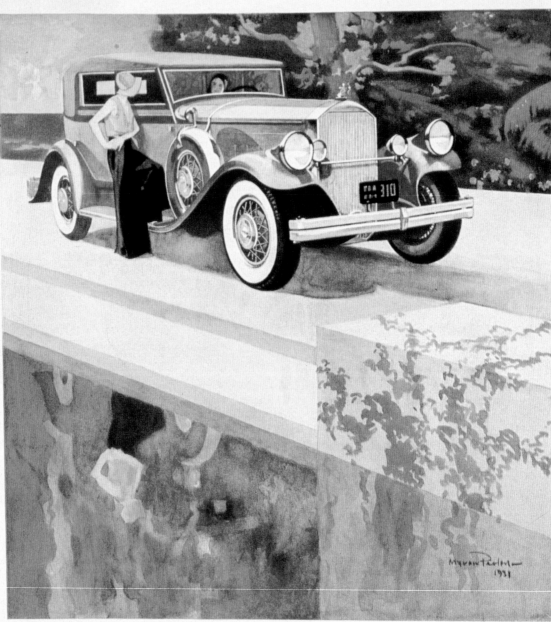

The Convertible Sedan of Group B . . . $3650 at Buffalo

SURVIVAL VALUE • A PIERCE-ARROW FUNDAMENTAL

What community today is without its ten- or twelve- or fifteen-year-old Pierce-Arrows . . . still superbly patrician, still rendering distinguished service to the original owners? Therein lies the deepest-rooted, most foundational, of all Pierce-Arrow characteristics —a quality that has been called *survival value*.

Because an essential part of its beauty is in its character . . . a part that is unchanging . . . the Pierce-Arrow of yesterday, or of a decade ago, finds complement in the smartest of today's models. And thus a great Pierce-Arrow fundamental becomes also a fine safeguard for each Pierce-Arrow owner's investment.

Twenty-nine New Models . . *with Free Wheeling* . . from $2685 to $6400 at Buffalo. (Other Custom-built Models up to $10,000.)

CHRYSLER
IMPERIAL EIGHT

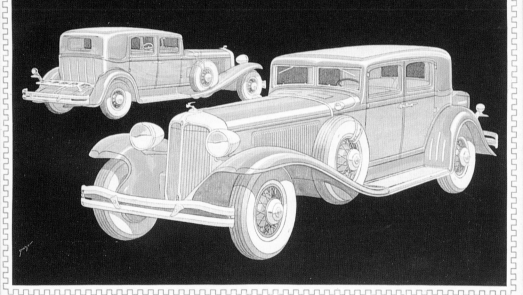

Front view and rear view of the Chrysler Imperial Eight Close-Coupled Sedan . . . faultlessly beautiful, viewed from any angle . . . 145-inch wheelbase . . . 125-horsepower . . . Multi-Range 4-speed transmission with Dual High gears . . . a motor car for the connoisseur of motor cars.

5-Passenger Sedan $2745; Close-Coupled Sedan $2845; 7-Passenger Sedan $2945; Sedan–Limousine $3145.
Custom Body Styles: Coupe $3150; Roadster $3220; Convertible Coupe $3320; Phaeton $3575. F. O. B. Factory.

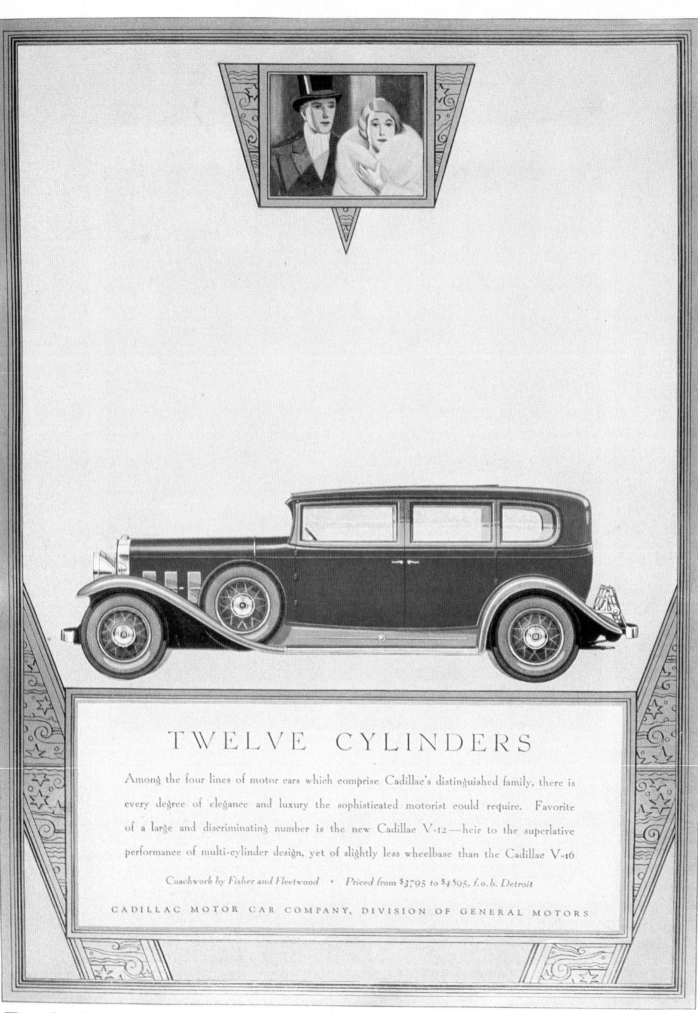

TWELVE CYLINDERS

Among the four lines of motor cars which comprise Cadillac's distinguished family, there is every degree of elegance and luxury the sophisticated motorist could require. Favorite of a large and discriminating number is the new Cadillac V-12 — heir to the superlative performance of multi-cylinder design, yet of slightly less wheelbase than the Cadillac V-16

Coachwork by Fisher and Fleetwood · Priced from $3795 to $4895, f.o.b. Detroit

CADILLAC MOTOR CAR COMPANY, DIVISION OF GENERAL MOTORS

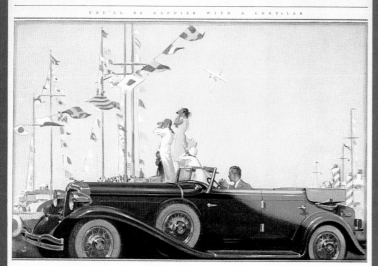
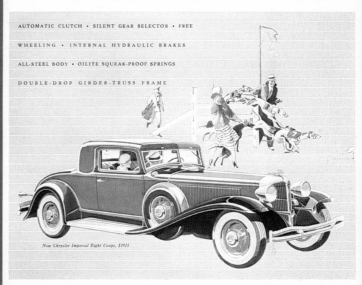

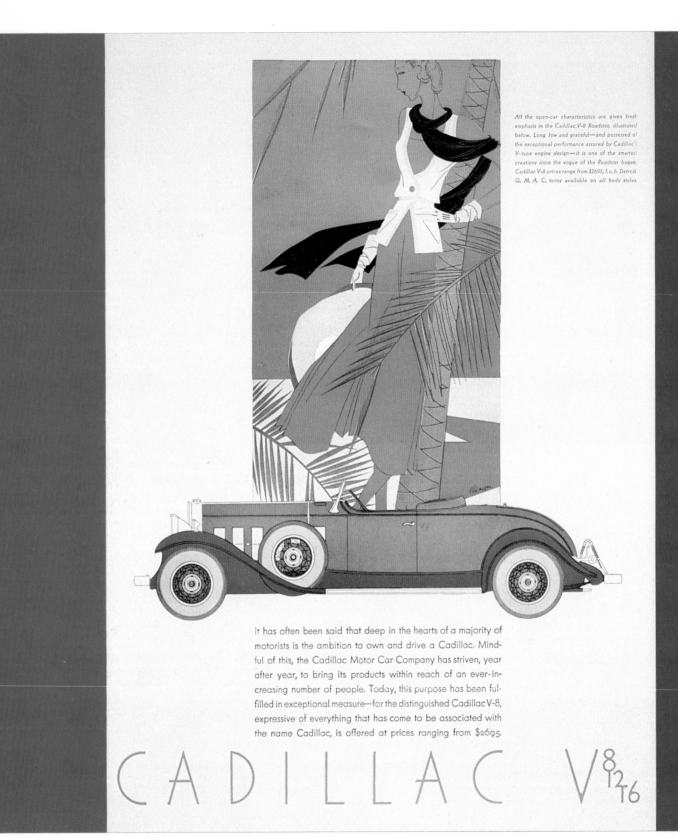

All the open-car characteristics are given fresh emphasis in the Cadillac V-8 Roadster, illustrated below. Long, low and graceful—and possessed of the exceptional performance assured by Cadillac's V-type engine design—it is one of the smartest creations since the vogue of the Roadster began. Cadillac V-8 prices range from $2695, f.o.b. Detroit. G. M. A. C. terms available on all body styles.

It has often been said that deep in the hearts of a majority of motorists is the ambition to own and drive a Cadillac. Mindful of this, the Cadillac Motor Car Company has striven, year after year, to bring its products within reach of an ever-increasing number of people. Today, this purpose has been fulfilled in exceptional measure—for the distinguished Cadillac V-8, expressive of everything that has come to be associated with the name Cadillac, is offered at prices ranging from $2695.

CADILLAC V8 12 16

For you who purchase with discernment, there is one guide which you can fully trust. It is the time-tried axiom, "The very best *economy* abides in *quality*." Many a Cadillac owner has voluntarily said that appreciation of this truth dictated his selection. And, in so choosing, he has signified conviction that Cadillac's designers have achieved their aim. . . . Cadillac, for more than thirty years, has striven unremittingly to earn for its products the approbation of those who cherish fine things. This high purpose has brought forth a succession of motor cars of literally superlative worth. . . . This, unquestionably, is true of the three superb cars which now carry the Cadillac crest. More skillfully designed and built; featuring, among many advancements, Fisher No Draft Ventilation, individually-controlled; and finer in every detail—they are obviously for those who want the finest quality, and recognize its economy. . . . So, whether you seek luxury, or performance, or inherent soundness—you will find it in fuller measure in these new Cadillacs. . . . The V-8 and V-12 are on display at all Cadillac-La Salle dealers'—while the V-16, limited to 400 cars for the current year, is custom built to order. Cadillac list prices begin at $2695, f. o. b. Detroit.

CADILLAC

A GENERAL MOTORS VALUE

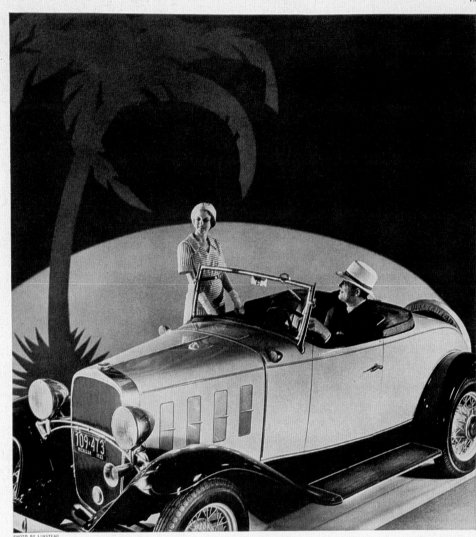

PHOTO BY LINSTEAD

WITH A BETTER RIGHT THAN EVER TO YOUR FAVOR

Among women of discrimination, correct personal transportation has long meant the Chevrolet Six. The *new* Chevrolet is designed to establish this tradition even more firmly than before. Its new Fisher bodies have the ultra-modern streamline silhouette so much in vogue among the better-known custom cars. Interiors have wide, deeply cushioned seats, beautifully tailored upholstery and smartly fashioned hardware. In the matter of performance Chevrolet has shown an equal understanding of women's requirements. The new Chevrolet Six is spirited and powerful to a high degree, yet even smoother and quieter than before. Syncro-Mesh is combined with Free Wheeling to give quiet, easy gear-shifting and positive car control. In fact, the Chevrolet Six makes so many *new* bids for feminine favor that it has already won wide acceptance among women with exacting ideas about personal transportation.

NEW CHEVROLET SIX

Priced as low as $475, f. o. b. Flint, Michigan. Special equipment extra. Low delivered prices and easy G. M. A. C. terms. Chevrolet Motor Co., Detroit, Michigan. Division of General Motors

THE GREAT AMERICAN VALUE FOR 1932

COACHWORK OF DISTINCTIO

Chevrolet has long had th
certain well-groomed air a
example of Chevrolet styl
model lay special stress
clean and smooth, with a
simplicity. Just enough
give the car sparkle and
quiet, luxurious way that
relaxation. Yet, distinctiv
tion lies in its performan
Chevrolet combines Free V

*Priced as low as $475,
and easy G. M. A. C. te*

THE GREA

107 Vanity Fair.1932.3

106 Vanity Fair.1932.2

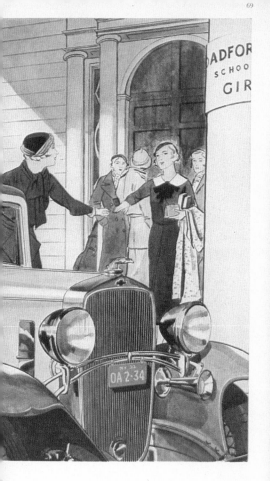

CAR OF LOWEST PRICE

turning out smart personal cars with a
ss the new Sport Coupe, a characteristic
ctive body by Fisher. The lines of this
and fleetness. The body-contours are
f anything that might detract from their
e been added, on radiator and hood, to
erior has been tailored and fitted in the
raftsmanship . . . and assures complete
n coachwork, probably its chief distine-
on to smooth multi-cylinder operation,
le, easy, non-clash Syncro-Mesh shifting.

pecial equipment extra. Low delivered prices
Detroit, Michigan. Division of General Motors.

NEW CHEVROLET SIX

RICAN VALUE FOR 1932

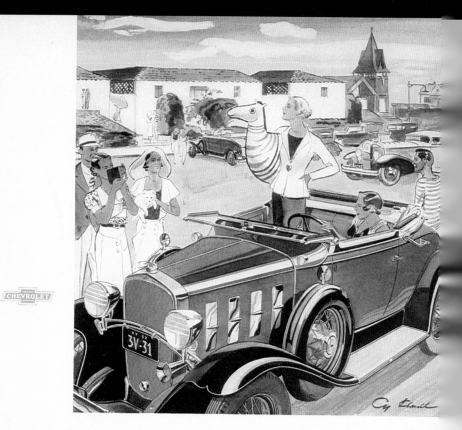

QUALIFIED IN EVERY WAY TO BE YOUR PERSONAL CAR

If you belong to that increasing group of women who insist on perfection of detail, you are sure to be drawn to the new Chevrolet Six. For here is a car with that well-groomed appearance you demand in all your personal possessions—presenting the new streamline silhouette in which all details blend in an effect of smart simplicity—bringing you handsomely appointed interiors of quiet, restful charm. A car so well proportioned that it gives you ample room, yet nestles cozily in tiny parking spaces. A car, moreover, so smooth, quiet and responsive, and so wonderfully easy to drive, that you seldom become aware of its mechanical details. And here is another point that it is well to remember when you set out to buy a car of your own: Only the Chevrolet, among inexpensive automobiles, combines Fisher bodies, a six-cylinder motor, and *both* silent, easy Syncro-Mesh gear-shifting and Free Wheeling. And *al* these, you'll find, are necessary to qualify an automobile as a personal car, today.

• • •

Priced as low as $445, f. o. b. Flint, Michigan. Special
equipment extra. Low delivered prices and easy G. M. A. C.
terms. Chevrolet Motor Company, Detroit, Michigan.
Division of General Motors.

NEW CHEVROLET SIX

☆ ☆ ☆ THE GREAT AMERICAN VALUE ☆ ☆ ☆

Superstars and Their Supercars

From the time of the talkies, Hollywood produced a stream of movie millionaires, such as Clark Gable, Gary Cooper, Tyrone Power, and Greta Garbo, whose taste in automobiles was expensive and luxurious. The favorite cars of the superstars were custom-made with bodies built by first-rate coach builders — the Duesenberg, the Pierce-Arrow, the Packard, and the Cadillac. Some of these cars cost as much as twenty thousand dollars in the days when a Ford or Chevrolet went for about five hundred dollars.

The two most popular actors of the time, Gable and Cooper, each bought a supercharged Duesenberg SSJ (maximum speed, 130 mph), together accounting for the entire limited edition of two.

During the time of Prohibition, gangland leaders in Chicago also made use of the best that the automobile industry had to offer. In fact, the first customer to order General Motors' V-16 Cadillac was none other than Al Capone. His car, of course, was completely bullet-proof, weighing, it is said, four tons.

PIERCE - ARROW

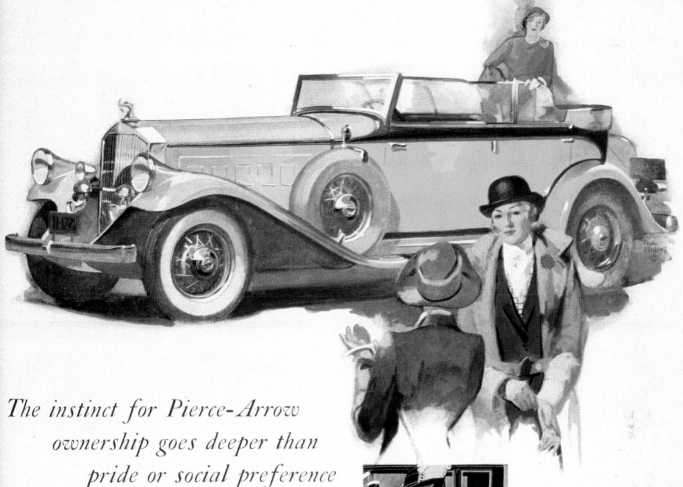

The instinct for Pierce-Arrow ownership goes deeper than pride or social preference

IT is bred of a deep-rooted, almost unconscious, conviction that Pierce-Arrow has always been built to standards singularly fine.

Many of the artisans whose skill is so brilliantly expressed in today's Pierce-Arrow Twelves and Eights came to Pierce-Arrow early in its career. They helped establish practices of precision manufacture which endure to this day. Such men, whose pride is in the deftness of their hands, work with gauges that measure four-millionths of an inch—with scales that register milligrams.

In an era when speed has become a fetish in manufacturing, the Pierce-Arrow plant at Buffalo remains the distinguished exemplar of painstaking hand-work . . . and the current Pierce-Arrow Twelves and Eights present Pierce-Arrow precision at its finest.

From a Pierce-Arrow advertisement published in 1910 comes this picture of what was then "America's Finest Car." Throughout the intervening 22 years, there has never been a rival for this Pierce-Arrow distinction.

TWO NEW TWELVES
142-inch to 147-inch wheelbase
150 horsepower
137-inch to 142-inch wheelbase
140 horsepower

Priced at Buffalo from . $3650

THE NEW EIGHTS
137-inch to 142-inch wheelbase
125 horsepower

Priced at Buffalo from . $2850

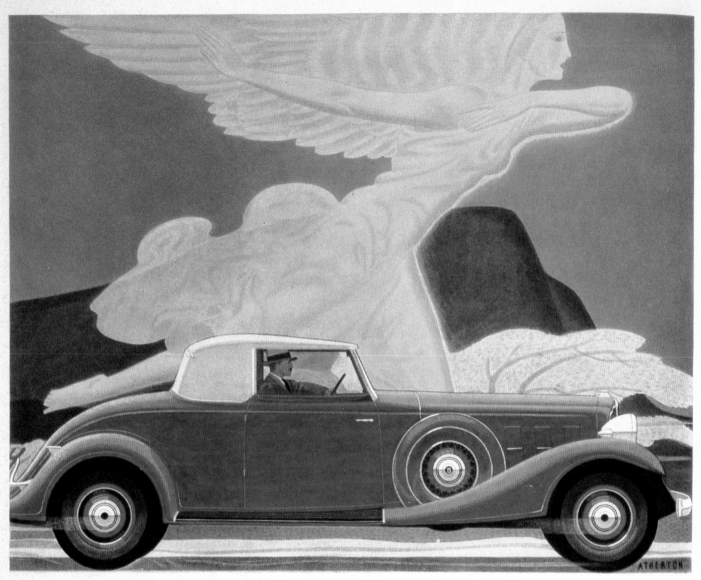

Refinement Evident in Every Detail

BUICK GIVES MORE AND BETTER MILES

In Europe .. in America .. and all the world around

It has been proved again and again, in all parts of the world, throughout thirty years, that Buick gives more and better miles. *Better* miles—naturally. The new Buick brings you the long wheelbase, the size and weight, which are absolutely necessary to real roadability and comfort. *More* miles, too. The records show that many, many Buicks are still serving after having gone 200,000 miles and more.

The *wise* place for your money, when buying a car, is a Buick. It satisfies your desires by its finer quality. It protects your purse by its longer, more trouble-free service. That is why this moderately priced Buick is such a favorite all 'round the world.

The twenty new Buick body-types are offered at moderate prices on the liberal and convenient G. M. A. C. payment plan. All are Buicks through and through. They have new Bodies by Fisher, Valve-in-Head Straight Eight Engines cushioned in rubber, and new Fisher No Draft Ventilation (Individually Controlled). All are fine, economical motor car investments.

CONGO

A prominent Belgian industrialist uses his Buick on blistering desert drives from Algiers to the Belgian Congo, and finds that "Buick gives more and better miles."

SWITZERLAND

The 6,440-foot climb up the St. Gotthard pass in the Alps is easy for Buick—which helps to explain why Buick is a favorite in Switzerland, too.

TURKEY

Buick cars won first and second place in Turkey's first motor race, at Istanbul in 1932, thereby strengthening their hold on the affections of motorists in that country.

CHINA

America's women, delighted with Buick beauty, will be interested in this flower-decked sedan of a Chinese bride—novel in style, but a Buick through and through.

'ROUND THE WORLD

Recently, a European Boy Scout drove his Buick 'round the world alone, and paid high tribute to its reliability when leaving America for his home.

WHEN BETTER AUTOMOBILES ARE BUILT, BUICK WILL BUILD THEM . . . A GENERAL MOTORS VALUE

PIERCE-ARROW

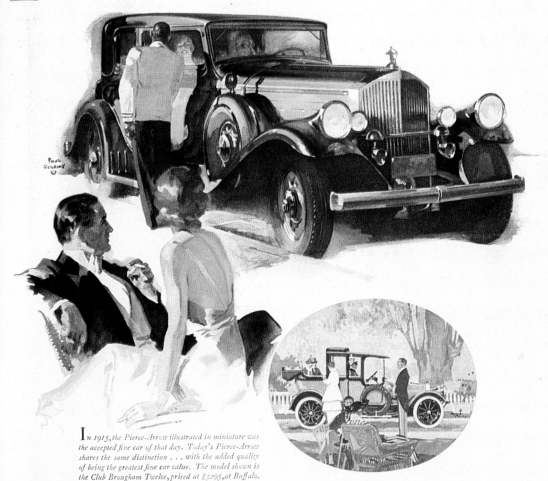

IN 1915, the Pierce-Arrow illustrated in miniature was the accepted fine car of that day. Today's Pierce-Arrow shares the same distinction . . . with the added quality of being the greatest fine car value. The model shown is the Club Brougham Twelve, priced at $3295, at Buffalo.

Product of This Searching and Sophisticated Hour

By reason of its singularly compact, self-contained facilities of fine car manufacture, Pierce-Arrow took early advantage of today's lowered commodity costs . . . and so was first to express new and markedly higher values in quality Eights and Twelves.

The new Pierce-Arrows, however, do more than exemplify the increased purchasing power of today's dollar. Their new heights of beauty and performance are far beyond anything in the present advanced fine car field.

Instead of compromising with fineness, Pierce-Arrow has given it even greater emphasis. There are, for example, more hours of skilled labor . . . incomparably fine handcraftsmanship . . . represented in the Pierce-Arrow engine alone, than in the entire structure of most cars.

It is thus literally the fact that Pierce-Arrow today needs no advocacy other than a brief experience behind or alongside the wheel of its exceptional creations . . . whether of eight cylinders or of twelve.

THE NEW EIGHTS
137" to 142" Wheelbase
125 Horsepower
Priced at Buffalo from

$2495

TWO NEW TWELVES . . . 142" to 147" Wheelbase . . . 150 Horsepower
137" to 142" Wheelbase . . . 140 Horsepower . . . *Priced at Buffalo from* **$3295**

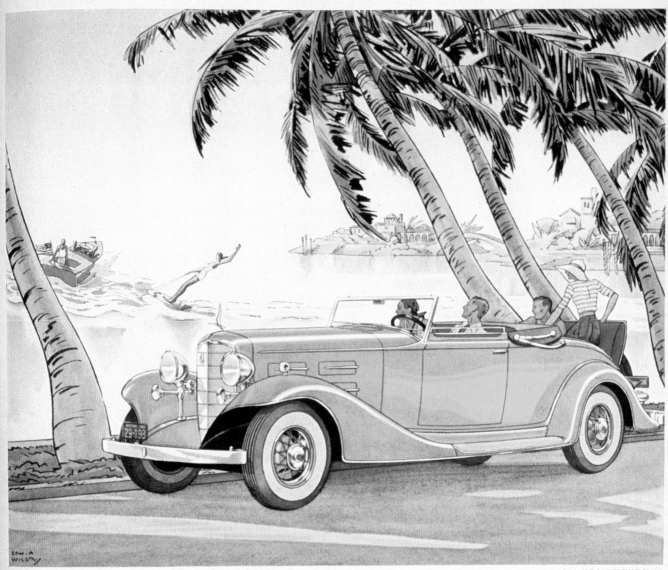

LA SALLE CONVERTIBLE COUPE

A FINER AND FAR MORE DISTINGUISHED La SALLE
. . . at an even more moderate price

It was an occasion for great rejoicing among men and women who admire fine possessions, when the new La Salle V-Eight appeared upon the American scene a few weeks ago. For here was something they had been seeking. Here was a motor car of proud lineage, enriched throughout in its quality—yet offered at prices in perfect keeping with the current economic scheme. . . . No need to question the correctness of the youthful grace which is the dominating note in its appearance—for the style of the new La Salle was created by the most accomplished designers at the command of the Fisher studios. No need to wonder about its mechanical fitness or the nature of its performance—for La Salle is the product of the same skilled craftsmen who build those magnificent motor cars, the Cadillac V-Eight, V-Twelve, and V-Sixteen. . . . The new La Salle is powered by the 115-horsepower Cadillac V-type eight-cylinder engine. Throughout chassis and body are many refinements and developments of major importance, including the new Fisher No-Draft Ventilation system, individually-controlled. Yet the standard five-passenger sedan is now reduced to $2245, f.o.b. Detroit—a price most attractively reasonable for a car of Cadillac design, Cadillac construction, and genuine Cadillac quality.

La SALLE V·8
A General Motors Value

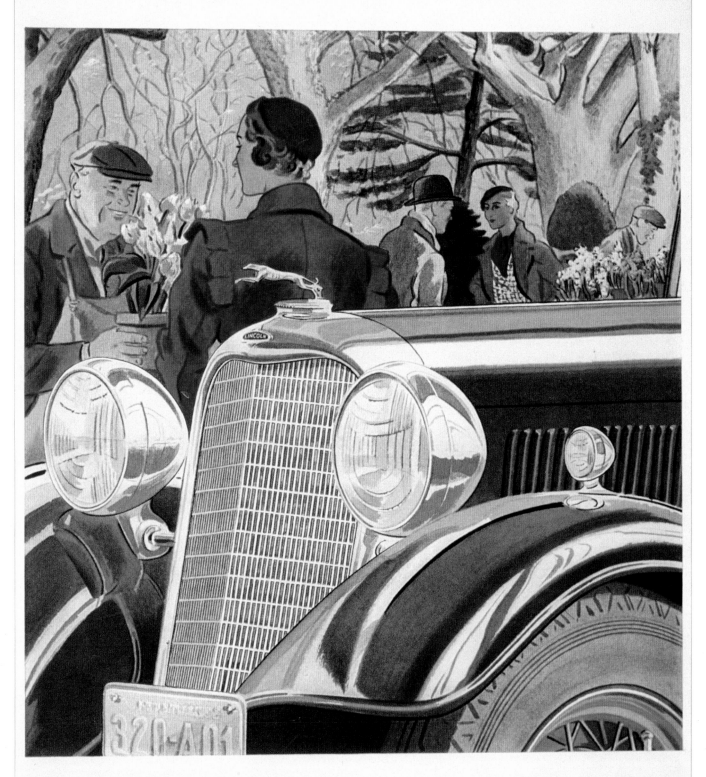

MORE THAN YOU WOULD EXPECT EVEN OF THE LINCOLN

EXPECTATIONS are high, naturally, as you take your place behind the wheel of a Lincoln, or rest at ease on relaxing cushions. But the motoring thrill of the new 12 cylinder Lincoln with 136-inch wheelbase is beyond anything you ever experienced . . . unless you are already familiar with Lincoln 12 cylinder motor cars.

An effortless smooth motion. An alert, unbelievably quick responsiveness. Ease of control. A feeling of security pleasantly reminding you that your motor car is a precision-built Lincoln.

Never before has Lincoln offered value as great as that found today in this new Lincoln 12-136. Here are typical Lincoln qualities and high mechanical standards presented at the lowest prices in Lincoln history . . . from $2700 at Detroit.

The Lincoln 12 with 145-inch wheelbase, and 150 horsepower, is the most luxurious Lincoln ever built. It is priced from $4200 at Detroit. You are cordially invited to test your own critical judgment with a demonstration of these new Lincoln motor cars.

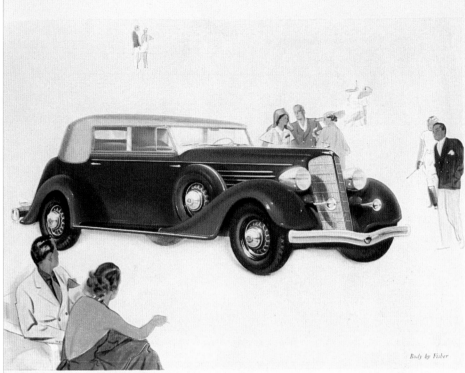

Body by Fisher

Speaking of the newest in motor cars

"Jack, this is *just* the car to take on our Northern trip! Imagine—rolling over the Alleghenies—climbing Mount Pocono—and surprising the Prestons in Montreal, with this beautiful new Buick."

"Wonderful—and I'm thinking of the smooth gliding ride that these Knee-Action Wheels will give us. Not a jounce or bounce all the way there. Why, you couldn't be more comfortable sitting at home."

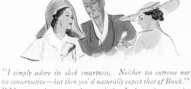

"I simply adore its sleek smartness. Neither too extreme nor too conservative—but then you'd naturally expect that of Buick."

"Mary, you just *cannot* be practical. Look at those oversize Air-Cushion Tires—and did you know the Vacuum-Power Brakes will stop you on a dime, with the very least pedal effort?"

"Just the same, you can't blame her for wanting style. As for me, I simply adore the freedom of its spacious interiors—and if you ask me, I am sold right now on automatic starting. It certainly would help improve my disposition."

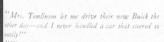

"Mrs. Tomlinson let me drive their new Buick the other day—and I never handled a car that steered so easily!"

"That's design, my dear. Whether it's style or engineering—design must be left to Buick. They've redesigned their steering to fit their new Knee-Action Wheels. Altogether, I've never seen such engineering improvements since I first started driving a car."

BUICK

for 1934 with
Knee-Action Wheels

WHEN · BETTER · AUTOMOBILES · ARE · BUILT · BUICK · WILL · BUILD · THEM

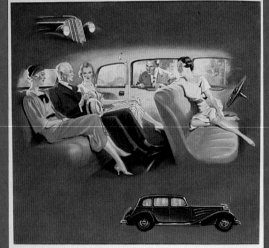

HOW DAD WON

He was respected for his analytical ability. He had inspected the 1934 Auburn's rigid frame. He was impressed with the fact that the chassis contains no untried experiments. He had had years of experience with Lycoming engines; in passenger cars, airplanes, boats, and trucks. His business acumen convinced him Auburn offers the greatest value. But it would appear that the feminine influence predominated in his home. So, Daughter got behind the wheel. The ample room, luxurious interior, and ventilation control won Mother and Sister over instantly. When they came home from a demonstration, amazed at Auburn's easy riding, the way the car clung to the road, the absence of side-sway, and the advantages of the Extra High gear of Dual-Ratio —well, the Auburn had sold itself

AUBURN

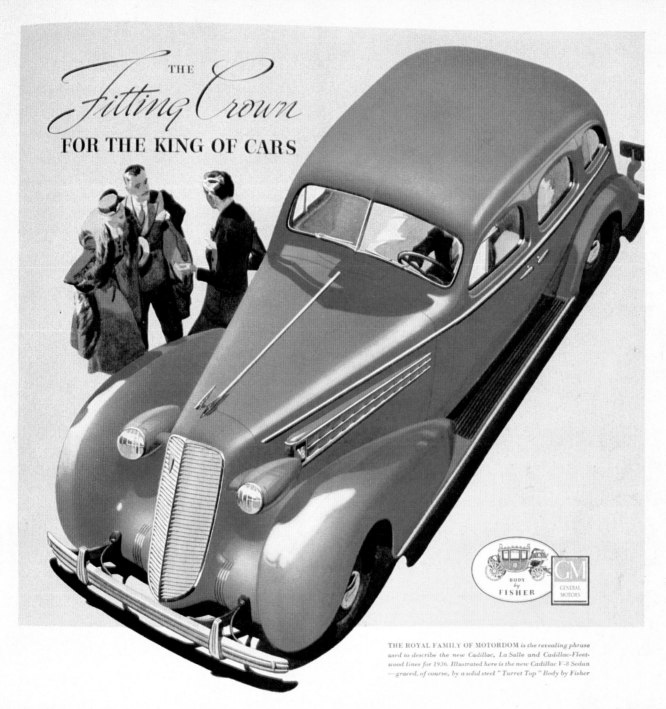

THE
Fitting Crown
FOR THE KING OF CARS

THE ROYAL FAMILY OF MOTORDOM *is the revealing phrase
used to describe the new Cadillac, La Salle and Cadillac-Fleet-
wood lines for 1936. Illustrated here is the new Cadillac V-8 Sedan
—graced, of course, by a solid steel "Turret Top" Body by Fisher*

HERE IS PICTURED THE NEW CADILLAC — handsomest version of "The Standard of the World" that the public has ever seen.

Crowning its majestic elegance and excellence now, as is fitting, is the solid steel "Turret Top" Body by Fisher.

That alone, almost as much as this great car's proud emblem, marks the new Cadillac as the last word in luxurious comfort, utmost safety and modern style.

The instant sweep to popularity of the solid steel "Turret Top" Body by Fisher is based on sound reasons of beauty, safety and utility.

Its smooth uncluttered contours enable smarter streamline styling, its arching roof of seamless steel affords greater safety, its sturdy unity of roof and body panels stiffens and reinforces the whole car assembly, and scientific insulation makes the "Turret Top" body cooler in summer and warmer in winter.

Not to have the "Turret Top" on the new car you buy is to deny yourself these important advantages*—so it pays to remember, that, like Body by Fisher, it is found *only* on General Motors cars.

An important additional advantage is Fisher pioneered and perfected No Draft Ventilation. This is an exclusive feature found only in cars with Body by Fisher — an improvement that has added to the health and comfort of millions of motorists

The Solid Steel "TURRET TOP" *Body by Fisher*

ON GENERAL MOTORS CARS ONLY: CHEVROLET · PONTIAC · OLDSMOBILE · BUICK · LA SALLE · CADILLAC

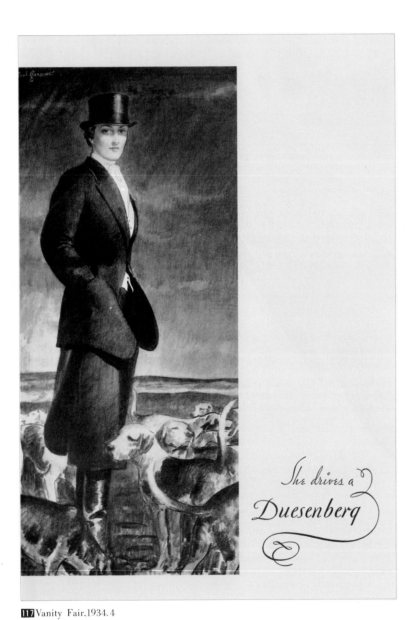

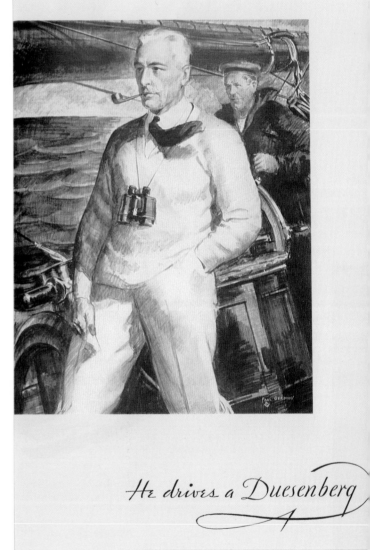

117 Vanity Fair.1934.4

118 Vanity Fair.1934.5

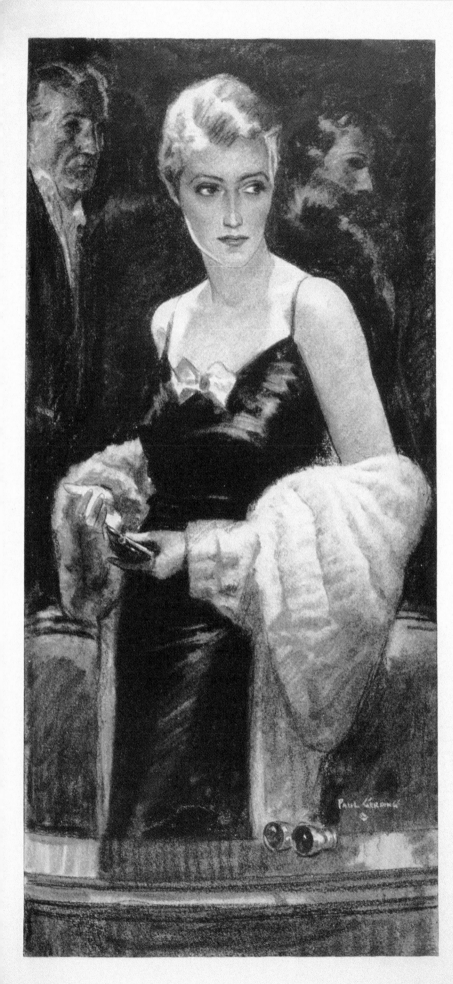

She drives a
Duesenberg

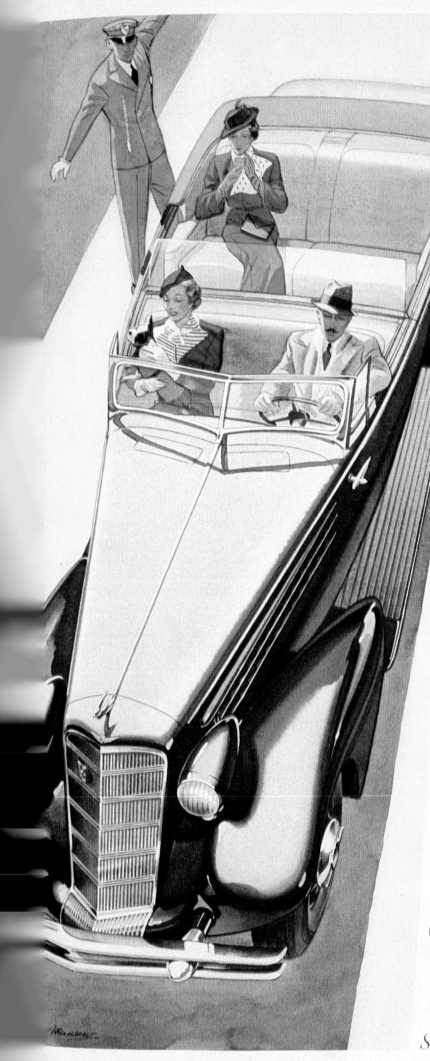

Incomparable !

The master violinist, desiring the supreme instrument of his art, chooses no more confidently than the man or woman desiring the finest motor car manufactured today. The one selects a Stradivarius; the other, a new Cadillac V-8, V-12 or V-16. The one obtains a mastery of musical tone that is without parallel; the other, a mastery of motoring pleasure that is likewise unique and individual. . . . If this seems, in any way, an exaggeration, the most casual inspection of the new Cadillacs and the briefest test of their abilities will convince you it is but a simple statement of truth. For these new Cadillacs, built to form the new standard of the world, oversweep Cadillac's traditional margin of superiority and attain a leadership that will amaze and delight you. . . . Their beauty is the complete embodiment of their designer's art—unrestricted by any limits as to cost. Their performance so far transcends anything you have known that even long trips will find you reluctant to surrender the wheel. Their comfort, their ease of control, their safety, all unite to produce that *complete enjoyment* which makes Cadillac the supreme instrument of luxurious motoring!...Won't you promise yourself, now, to examine and ride in these new cars? You'll find but one word with which to describe them. They are simply *incomparable!*

C A D I L L A C

S t a n d a r d o f t h e W o r l d

American Automobile Makers, Their Makes and Models

The biographies below are arranged alphabetically by automobile name. Prior to the thirties, most cars were named after the companies that produced them; Ford cars, for example, were made by the Ford Motor Company. Exceptions to this practice are noted in the text.

• **Auburn, 1900 — 1937** *(Figure 115)*
The Auburn was very warmly welcomed by a certain segment of the buying public because of its original styling and excellent speed. As with many of the old originals, replicas continue to be made of this representative American classic car.

Each year, Auburn, Indiana (where the car was produced), hosts the Auburn Classic Car Parade, which attracts participants and observers from all over the country.

Figure 115 shows the 1934 Auburn Salon, which came in twelve models in either six or eight cylinders.

• **Baker Electrics, 1899 — 1916** *(Figures 9, 24, 25, 26, 40, 41)*
From 1902 to 1910 during the early days of the automobile, electric cars such as the Baker were quite popular with the driving public, especially women. Unlike steam- and gasoline-driven cars, electric cars were easy to start and maneuver, rode silently, and did not pollute the air with exhaust fumes.

In 1909, a Japanese resident of the United States presented the Japanese emperor with a two-passenger Baker Victoria. The popularity of this car was due in part to the emphasis the Baker R & L Company placed on high-quality advertising. By 1910, in fact, Baker ranked first in *Life* magazine's list of advertisers.

• **Buick, 1903 — Present** *(Figures 53, 61, 62, 64, 80, 110, 114)*
The Buick is an upper-middle-class car produced by a division of General Motors whose motto has always been When Better Automobiles Are Built, Buick Will Build Them.

The original makers of the Buick went bankrupt in 1904, and the company was bought by W.C. Durant, who later founded General Motors. In 1908, when General Motors was created, Buick became the parent company.

Figure 53 shows the Brougham Master Six, a prototypical car of the twenties. Buick continued in this style through the thirties until 1934, when Harley Earl introduced his novel design ideas and the company added an independent suspension system. *Figure 114* shows the result of these changes.

• **Cadillac, 1903 — Present** *(Figures 59, 70, 101, 104, 105, 120)*
When thinking of American luxury cars, one thinks first of the Cadillac, a symbol of wealth and power for so many years. Originally an independent automobile manufacturer, Cadillac was bought by General Motors in 1909, and the Cadillac has been GM's flagship car ever since.

The Cadillac division has always been technically innovative and eager to live up to the motto shown in their advertisements — Standard of the World. Cadillac developed the V-8 engine in 1914; crank shaft with balancer in 1924; the V-12 and V-16 engines in 1930; and independent suspension in 1934. *Figures 104, 105,* and *120* show the V-8, V-12, and V-16 series, which represent the age of multicylinder, large-displacement engines. A car from this group was characterized by its sporty styling, the long hood, and the chrome horn attached above the large front fender.

• **Chalmers, 1908 — 1924** *(Figure 38)*
When the Chalmers Six shown in *Figure 38* was produced, the Chalmers Motor Company was a medium-sized manufacturer making approximately twenty thousand cars per year. After World War I, however, the company's business deteriorated rapidly, and Chalmers merged with Maxwell to become Maxwell Chalmers (the predecessor of Chrysler).

The Chalmers Six was a seven-passenger open–bodied car with a maximum speed of 60 mph.

• **Chevrolet, 1911 — Present** *(Figures 93, 106, 107, 108)*
This most orthodox of cars has appealed to the American public since its debut in 1911. Until 1950, one in every eight cars is said to have been a Chevrolet; and since 1927, Chevrolet has been the best-selling American car in the United States.

Chevrolet, which was established in 1911, was bought by General Motors during World War I in 1918 and became the Chevrolet division of GM. The Chevrolet Six, which was originally developed in the thirties as direct competition for Ford's Model A, became the talk of the town through General Motors' aggressive ad campaign that made such claims as "You can buy a six-cylinder for the price of a four-cylinder" and "It's wise to choose a six."

If you wonder where the name came from, it originates with Louis Chevrolet, the French racer connected with the Buick manufacturing plant.

• **Chrysler, 1923 — Present** *(Figures 100, 102, 103)*
When Maxwell Chalmers succumbed to financial difficulties in 1923, it was purchased by former General

Motors executive Walter P. Chrysler, who renamed the company Chrysler in 1925.

Through positive and aggressive business decisions, the Chrysler Corporation expanded its influence and gained nearly a 25 percent market share of the automobile industry by 1933 to become (with GM and Ford) one of the Big Three automobile makers.

Until 1950, Chrysler's product line consisted of Plymouth, Dodge, DeSoto, and Chrysler. *Figures 100, 102* and *103* show the Chrysler Imperial Eight—Chrysler's highest-quality car.

• Cole, 1909 – 1925 *(Figures 42, 47)*

The Cole, which was developed by an Indianapolis carriage maker, initially produced just two models—the four- and six-cylinder Cole. The Cole Aero-Eight, however, debuted in 1916 and was the company's strongest product in the twenties. Due to poor sales, the company went out of business in 1925.

• Columbia, 1897 – 1913 *(Figure 16)*

The Columbia Motor Car Company began by producing electric cars and eventually turned to the manufacture of gasoline-engine automobiles. By 1905, after its four-cylinder, six-passenger model was introduced, the company was the largest car manufacturer in the country.

The improved models introduced in 1907 and 1911 could not, in the end, compete with such mass-produced, low-priced cars as Ford's Model T. In 1913, the Columbia Motor Car Company went bankrupt.

• Dodge 1914 – Present *(Figure 77)*

Brothers John and Horace Dodge originally were subcontractors for the Ford Motor Company. In 1919, the brothers broke from Ford to become an independent car manufacturer. The first cars produced by Dodge had four cylinders; the company later advanced into the six-cylinder market and eventually emerged as a solid, medium-sized manufacturer.

In 1928, Dodge was purchased by Chrysler and continues to be a popular car to this day.

• Duesenberg, 1920 – 1937 *(Figures 117, 118, 119)*

The Duesenberg, alias "the mightiest American motor car," was the country's most luxurious high-class car of the classic era. Considered by many to be *the* American dream car, the Duesenberg had a custom-made body and was not cheap—the prices ranged from $3,500 to $20,000. In seventeen years of operation, the company produced only 650 cars.

Figures 117 through *119* show three ads from Duesen-

berg's advertising campaign of 1934–1935. The elegance of the illustration matches the rich simplicity of the text: "She (he) drives a Duesenberg."

• Erskine, 1926 – 1930 *(Figure 71)*

Billed as the "small Studebaker," the six-cylinder Erskine was named for Studebaker president Albert R. Erskine. The three models produced included the Tourer, the Custom Sedan, and the Business Coupe.

• Fisher Body, 1908 – Present *(Figures 98, 116)*

Fisher Body was an independent manufacturer of car bodies for eleven years before General Motors acquired 60 percent of the company's stock in 1919. In 1925, Fisher became a full subsidiary of GM, and General Motors used "Body by Fisher" in most of its advertising.

Figure 116 shows the solid steel roof, called a Turret Top, developed by Fisher in 1933. Until then, car roofs were made of stretched canvas and hardened tar.

• Ford, 1903 – Present *(Figures 54, 55, 56, 57)*

The Ford Motor Company was established by "automobile king" Henry Ford, who developed the process of mass-producing cars on an assembly line. Almost since its inception, Ford has been one of the most powerful and successful car companies in the United States. The company was so successful after introducing mass production, in fact, that it sold over fifteen million Model T's between 1908 and 1927 throughout the world.

The Model T shown in all four advertisements is a late-model closed-body car that was hastily developed to compete with the Chevrolet sedan. The three versions of this Ford included the two-door sedan, the four-door sedan, and the coupe.

• Franklin, 1901 – 1934 *(Figures 84, 85)*

For the entire thirty-three years of its existence, the Franklin Automobile Company used the same air-cooled engine in all of its cars. In the thirties—the age of multicylinder, large-displacement engines—Franklin introduced an air-cooled, twelve-cylinder car.

The company thrived because of such unique features as leaf-spring suspension and a wooden chassis. Like many companies of the day, however, Franklin could not survive the Depression and went bankrupt.

• Haynes-Apperson, 1898 – 1904 *(Figure 1)*

Developed by American auto pioneer Elwood Haynes and carriage manufacturer Apperson, the Haynes-Apperson was an early gasoline-engine car that came in two and four cylinders. Like many other "horseless carriages" in

the first years of the automobile industry, the car used a steering rod instead of a steering wheel.

• Hupmobile, 1908 — 1940 *(Figures 13, 66, 67, 89, 90)*
The Hupp Motor Car Company was founded by Bobby Hupp, the right-hand man of Ransom E. Olds, who established Oldsmobile.

Figure 13 shows the company's first car, which was equipped with a four-cylinder, 20-horsepower engine. In 1925, Hupp introduced the first mass-produced eight-cylinder car and established the company's reputation as a successful manufacturer. Unfortunately, the Hupp Motor Car Company could not resist the negative influence of the Depression and the competition of the Big Three automakers — General Motors, Ford, and Chrysler — and collapsed in 1940.

• Jeffery, 1914 — 1917 *(Figures 36, 37)*
A Wisconsin manufacturer of middle-class cars, the Thomas B. Jeffery Company originally produced four- and six-cylinder models under the name of Rambler. After the name change to Jeffery in 1914, the company's sales deteriorated, and the company was bought by Nash in 1917.

• Jordan, 1916 — 1931 *(Figures 49, 58)*
The Jordan Motor Car Company was established by Thomas Ned Jordan, a one-man team who was owner, art director, and copywriter of his company. For more information on the man and the car see "Somewhere West of Laramie" earlier in this book.

• La Salle, 1927 — 1940 *(Figure 112)*
Designed by Harley Earl, the stylish La Salle was introduced by General Motors' Cadillac division in 1927 as a low-cost version of the Cadillac. Automobile critics of the day praised it as "the American car with the most beautiful body." The La Salle was very popular — in part because of its low price ($1,446) in comparison to the price of the cheapest Cadillac ($1,752).

• Léon Rubay, 1922 — 1924 *(Figures 48, 51)*
The Rubay Company of Cleveland, Ohio, began selling the small, European-looking Léon Rubay Brougham, Coupe, Sedan, Cabriolet, and Berline in 1922.

The car was most successful on the East Coast, especially in New York City, but the company could not sustain itself with such limited popularity. After stopping production in 1924, the company was purchased by the Baker R & L Company, the electric car manufacturer.

• Lexington, 1909 — 1928 *(Figures 44, 45, 46)*
First established in Kentucky, the Lexington Motor Com-

pany moved to Indiana and began to produce four-cylinder cars in 1909 and six-cylinder cars in 1915.

One of the main selling points of the Lexington was its many body types. One of the main drawbacks was the high price caused by low production — six thousand cars in the company's peak year. In 1928, the company was purchased by the Auburn Automobile Company.

• Lincoln, 1920 — Present *(Figures 73, 74, 75, 76, 95, 113)*
Henry Leland, the father of the Cadillac, introduced the Lincoln in 1920. After just two years as an independent company, Lincoln was purchased by the Ford Motor Company to function as Ford's luxury-class car. Since 1924, in fact, U.S. presidents have used a Lincoln as the presidential limousine.

Figures 73 through 76 show the V-8 Lincoln of the twenties. Figure 113 shows Lincoln's twelve-cylinder model with a high-displacement engine.

• Lozier, 1905 — 1917 *(Figures 20, 23)*
The Lozier was an early high-class sports car that won the Vanderbilt Cup Race in 1911. The two versions produced — a six-cylinder, 51-horsepower model and a four-cylinder, 46-horsepower model — were highly priced ($5,000 and $4,700, respectively). The text of the ad in Figure 20 is very direct in describing the type of customer the company tried to attract — "people of wealth and discrimination."

• Marmon, 1902 — 1933 *(Figures 65, 94)*
Known as the car that won the first Indianapolis 500 in 1911, the Marmon had a reputation for durability and dependability, especially on bad roads.

Figure 65 shows the Speedster, a popular model from the early to mid-twenties. Figure 94 shows Marmon's 125-horsepower Big Eight from the late twenties. In 1931, during the Depression, Marmon introduced their last model, a sixteen-cylinder convertible. In 1933, the company went bankrupt.

• Maxwell, 1904 — 1925 *(Figure 11)*
Founded in 1904 by Jonathon Maxwell and Benjamin Briscoe, the Maxwell-Briscoe Motor Company first produced the two-cylinder Maxwell and then moved into four-cylinder models. By 1917, the company was selling 100,000 cars a year. In 1923, however, Maxwell-Briscoe found itself in financial difficulties and was purchased two years later by Walter P. Chrysler, who changed the name to Chrysler and gave the company a new beginning.

Figure 11 shows an early Model G Maxwell.

• Moon, 1907 — 1930 *(Figure 52)*
One of the few car manufacturers located outside of

Detroit, the Moon Motor Car Company advertised its car as "the luxury car of St. Louis." The Moon was an expensive automobile and made use of the highest-quality components, including a Continental engine, a Warner transmission, Timkin axles, and Lockheed brakes.

Despite its appeal to the richer segment of the population, the Moon Motor Car Company, founded by Joseph Moon in 1907, succumbed to the Depression and went out of business in 1930.

• Nash, 1917—1954 *(Figure 72)*
In 1917, Charles W. Nash, a former General Motors Buick division general manager, purchased the Thomas B. Jeffery Company and changed the name to Nash. At first, the company built cars for middle-class buyers; after purchasing LaFayette and Mitchell, however, Nash began to produce cars with more luxury-conscious buyers in mind.

In 1937, Nash merged with household electrical appliance manufacturer Kelvinator and became Nash-Kelvinator. In 1954, after merging with Hudson, the company became the present-day American Motors.

Figure 72 shows the 1927 Nash six-cylinder Special Sedan.

• Oakland, 1907—1931 *(Figures 31, 79)*
Originally a carriage manufacturer from Pontiac, Michigan, the Oakland Motor Car Company was founded by Alanson Brush, the designer of the first Cadillac. In 1908, the company was taken over by General Motors, where the Oakland became the precursor to the Pontiac and was billed as a middle-class car between Oldsmobile and Buick. In 1931, the Oakland was discontinued when the Pontiac line was introduced.

Figure 31 shows Oakland's Model 42, a five-passenger touring car. *Figure 79* shows one of Oakland's last models, the All-American Six.

• Oldsmobile, 1896—Present *(Figures 17, 18)*
Created by Ransom E. Olds, the Oldsmobile is America's oldest automobile brand that is still produced. General Motors bought the Olds Motor Works in 1908, and Oldsmobile has continued since that time as one of GM's high-class divisions.

Figures 17 and *18* show the early four- and six-cylinder models, which did not have self-starters. In *Figure 18* the crank handle can be clearly seen under the radiator grill.

• Packard, 1899—1958 *(Figures 82, 87)*
The quality of the Packard in its prime was considered to be higher than that of Cadillac or Lincoln, and the car was bought and appreciated by the rich throughout the world.

Before and after World War II, in fact, the Japanese imperial family used a Packard as its official car. The theme of the ads in *Figures 82* and *87* is "luxurious transportation," a claim that no Packard owner ever considered an exaggeration.

• Paige, 1908—1927 *(Figure 63)*
Advertisements for the Paige always emphasized style and appealed to the buyer's eye for beauty. "The most beautiful car in America," as the ad in *Figure 63* states, came in various sizes at various prices. Paige's Daytona Roadster was one of the top selling cars of its day (1922). The company was taken over in 1927 by Graham Page Motors.

• Peerless, 1900—1931 *(Figures 8, 10, 15, 19)*
Along with Pierce-Arrow and Packard, Peerless was one of the so-called Three P's of luxury car makers. In the twenties, however, when most car makers changed models yearly to attract new buyers, Peerless could not compete and finally went out of business in the Depression.

As the brand name suggests, Peerless was known for its high-quality materials and workmanship. The ads shown in the figures listed above represent early models of the Peerless at the beginning of the twentieth century.

• Pierce-Arrow, 1901—1938 *(Figures 2, 5, 6, 7, 14, 28, 29, 30, 81, 83, 92, 97, 99, 109, 111)*
Pierce-Arrow (originally Pierce) concentrated on perfection in car making, and the company's advertisements emphasize the importance of hand-crafted coachwork, interiors, and "mechanism." Billed as "America's finest car," the Pierce-Arrow was a high-quality automobile with a matching high price. Due to high production costs and sliding sales, the company gradually began to slip in the thirties and was purchased by Studebaker in 1938, where it eventually disappeared.

Pierce-Arrow was always a very aggressive advertiser, making sure that the beauty of the ads matched the beauty of the car itself. Note that, in many of these figures, the only text appearing in the ad is the name of the car. The ads were commercial and artistic at the same time.

• Pope-Hartford, 1903—1914 *(Figure 22)*
The Pope Manufacturing Company was established by Civil War hero Colonel Albert Pope and produced gasoline-engine cars (the Tribune, the Trade, and the Hartford) and commercial vehicles. In 1912, the company expanded into a four-cylinder, 50-horsepower engine and

a six-cylinder, 60-horsepower engine. By 1914, however, the company could not compete in the fierce pricing competition that resulted after the appearance of the Model T Ford, and Pope-Hartford disappeared.

• **Rauch & Lang, 1905 – 1915** *(Figure 33)*
The Rauch & Lang Carriage Company of Cleveland, Ohio, produced electric cars, the most popular of which was the boxy town car shown in *Figure 33*. The company, which also produced a four-door model and a six--passenger model, merged with Baker Electrics in 1916 to become the Baker R & L Company.

• **Reo, 1904 – 1936,** *(Figure 96)*
Ransom E. Olds, who founded the Olds Motor Works and then retired from the company, took the initials of his name and started the Reo Motor Car Company in 1904. *Figure 96* shows the 1931 Reo-Royale Eight, an eight--cylinder car with a 5.9-liter engine. In 1936, the company ceased production of passenger cars and limited its manufacturing to trucks.

• **Ruxton, 1929 – 1931** *(Figure 88)*
Perhaps the first designer car, the Ruxton was a car truly created by committee. According to the ad in *Figure 88*, twelve wealthy people came together to produce the perfect automobile and took two years and a few of the brightest automotive minds to make "a car so low you can look over it, a car so smart none can overlook it."

The Ruxton was a front-wheel-drive car produced for New Era Motors by Moon and designed by A. M. Andrews, a former designer of the Hupp Motor Car Company. The unusual eight-cylinder, 94-horsepower car had the gear boxes facing forward and the engine opposite. The Ruxton was in production for only a bit more than a year, and only about five hundred were made.

• **Simplex, 1907 – 1917** *(Figure 43)*
The Simplex Automobile Company popularized the Simplex by competing in car races in all parts of the country, even though the car never won a single race. In 1912, the car was renamed the Crane Simplex, after designer Henry Crane, but the car's performance continued to be less than perfect, and the company ceased production in 1917. *Figure 43* shows the Crane Model, which is still admired for its beautiful Brewster body.

• **Stearns, 1899 – 1930** *(Figures 12, 78)*
The F. B. Stearns Company of Cleveland, Ohio, began making high-priced, high-quality cars in 1908, and these elegant productions were also known by another name —

Cleveland Deluxe Cars.
In 1920, the company produced cars with Knight engines, which improved sales considerably. With the Depression, however, sales slided and production eventually stopped completely.

• **Stevens-Duryea, 1902 – 1927** *(Figure 27)*
Produced by J. Stevenson, a parts and tool maker, and designed by J. Frank Duryea, the younger of the two Duryea brothers who invented the gasoline engine, the Stevens-Duryea automobile was America's first six--cylinder car.

The Stevens-Duryea Company was bought in 1923 by Baker, the electric car maker.

• **Stoddard-Dayton, 1905 – 1913** *(Figures 4, 21)*
The Dayton Motor Car Company of Dayton, Ohio (and later of New York City), which produced Stoddard-Dayton automobiles, joined twelve other car makers to form U. S. Motors, a corporation that did not survive.

Figure 4 shows the six-cylinder, 50-horsepower limousine that first sold in 1907. *Figure 21* shows the Saybrook, the major model of 1910. Apart from these, two other models were produced — the Silent Knight (with a Knight engine) and the Savoy, the most economical of the Stoddard-Dayton line in 1912.

• **Studebaker, 1902 – 1964** *(Figures 69, 86)*
Originating in the largest horse-carriage manufacturer in the world, in South Bend, Indiana, Studebaker produced their first car, an electric, in 1902. In 1904, Studebaker produced its first gasoline-powered car — the Studebaker Gafford — and was known in its lifetime as a maker of middle-class cars.

Figure 69 shows a six-cylinder Commander Sedan from the late twenties. *Figure 86* shows the President Eight Convertible Cabriolet, an eight-cylinder, four--passenger classic.

• **Stutz, 1911 – 1935** *(Figures 50, 68)*
The Stutz Motor Car Company of America, Inc. produced a truly unique American-born sports car. The Stutz won many big races (the Indianapolis 500, the Vanderbilt Cup, etc.) and was very safety-oriented in the company's later years. The New Safety Stutz shown in *Figure 68*, in fact, had safety as its selling point and came with a one-year insurance policy.

• **Waverley Electric, 1908 – 1914** *(Figure 32)*
The Waverley Company produced electric cars in Indianapolis, Indiana, and the four-passenger limousine was

its specialty. After only six years, however, the company stopped production due to the success of gasoline-driven automobiles. *Figure 32* shows the company's last model.

• White, 1900 — 1918 *(Figures 3, 34)*

Figure 3 shows the White Steam Carriage produced by the White Sewing Machine Company of Cleveland, Ohio. The White had a reputation for dependability and, according to the ad copy, came through a reliability race from New York to Boston and back "without stop or trouble of any kind." In 1906, the White was chosen as President Theodore Roosevelt's official car.

Figure 34 shows a gasoline-powered White with a 3.5-liter engine, which was put on the market in 1910.

In 1918, the company stopped production of private cars and began to specialize in trucks.

• Wills Sainte Claire, 1921 — 1926 *(Figure 60)*

This six-cylinder car was produced by a small manufacturer in Marysville, Michigan, which used a flying grey goose as its trademark. Like so many car makers of the time, the company could not keep up with consumer demands for annual model changes and folded after five years.

• Willys, 1909 — 1963 *(Figures 35, 39, 91)*

In 1910, the Willys-Overland Company was the No. 2 car maker in the country, second only to Ford. The Willys-Knight (see *Figure 39*), which had an engine developed by Charles Y. Knight, was the company's best-selling car. (The Knight engine had little vibration and smooth revolutions and was used by other companies, such as Mercedes and Stearns, as well.)

Although already a well-known car maker with a long history, Willys-Overland achieved worldwide fame during World War II with its four-wheel-drive Jeeps used by the military.

Historical Chart of the American Automobile Industry
(1893–1939)

1893 Charles E. Duryea produces America's first gasoline-powered car.

1894 Elwood Haynes' steam-cylinder engine sets a 6 mph record on a test drive.

1895 The first auto maker in the United States — the Duryea Motor Wagon Company — is founded.
G. B. Selden's patent for the "car that runs by gasoline engine" is approved.
Of the three hundred cars owned by Americans, only four are American-made.

1896 Henry Ford introduces his Quadricycle — a two-cylinder, 4-horsepower experimental car.
Alexander Winton creates the two-passenger, gasoline-powered car.

1897 The Olds Motor Works is founded by Ransom E. Olds.
The Winton races from Cleveland to New York in ten days.

1898 A taxi company, using electric cars, opens in New York.

1899 The first showroom for cars opens at 120 Broadway in New York City, and the Winton is put on display.

1900 The first All-America Automobile Show is held at Madison Square Garden in New York City.
A gasoline-powered car competes with electric and steam cars in Chicago and, for the first time, wins the race.

1901 The world's first mass-produced car, the curved-dash Oldsmobile, sets an annual sales record of 425 cars.
Oil fields are discovered in Texas, and oil prices drop sharply.

1902 The Cadillac Motor Car Company is founded.

1903 The Ford Motor Company and the Buick Motor Company are founded.
Ford puts the two-cylinder Model A on the market.
The Winton crosses the continental United States (from New York to San Francisco) in a record sixty-three days.
Of cars made by the 246 manufacturers in the country, 106 are powered by steam, 41 by electricity, and 99 by gasoline.

1904 Ransom E. Olds retires the Olds Motor Works and founds the Reo Motor Car Company.
The first Vanderbilt Cup Race is held in Long Island.

1905 Of 212 cars exhibited at the Fifth All-America Automobile Show in Madison Square Garden, 177 were powered by gasoline, 31 by electricity, and 4 by steam.

1906 A Franklin drives from New York to San Francisco in fifteen days, two hours, and fifteen minutes.

1907 The Oakland Motor Car Company is founded.

1908 The General Motors Company, forerunner of present-day GM, is founded.
Ford introduces its Model T.

1909 The Hudson Motor Car Company is founded.

1910 The United States Motor Car Company is formed by 130 car makers.

1911 The Chevrolet Motor Company is founded.
Studebaker is founded.

1912 Cadillac adopts the electric self-starter.
Oakland and the Hupmobile put all-steel-body cars on the market.

1913 Model T Fords use streamline production methods to produce one thousand cars per day.

1914 World War I begins.
Ford adopts an eight-hour workday, paying five dollars a day.
Detroit erects traffic signs, and Cleveland erects traffic lights.

1915 Ford reaches the one-million mark in car production.
Packard introduced the Packard Twin Six.

1916 Studebaker sends its $25,000 car to a motor show.

1917 U.S. car makers stop production of private automobiles to make airplane engines and military vehicles for World War I.

1918 Parts to extend the car's life become hit sales items during the war when no new cars are produced. Non-driving days are also initiated in various parts of the country to conserve gasoline.

1919 The General Motors Acceptance Corporation, specializing in the installment-plan purchasing of cars, is founded. The "drive now, pay later" age begins.

1920	The Duesenberg, the first American car with a series-wiring, eight-cylinder engine and four-wheel hydraulic brakes, is introduced.
1921	Due to the recession following World War I, car production drops.
1922	The Ford Motor Company buys out the Lincoln Motor Company to enter the high-class market in automobiles.
1923	Car sales in the United States surpass the 1,500,000 mark.
1924	Almost all steam and electric cars disappear from the market, and sedans (closed-body cars) become popular. Ford introduces the closed Model T Ford.
1925	Maxwell-Chalmers becomes the Chrysler Corporation.
1927	Ford stops producing the Model T. The La Salle, the lower-priced Cadillac, is introduced.
1928	Ford introduces the Model A. Chrysler absorbs Dodge Brothers, Inc.
1929	The New York Stock Exchange collapses on October 24. American automobile production breaks the 5,350,000 mark, and 90 percent of all cars have closed bodies (in 1919, 90 percent had open bodies).
1930	The Great Depression causes car sales and the number of car makers to decline. Cadillac introduces its V-12 and V-16 cars.
1931	The Depression worsens, and many small- and medium-sized manufacturers collapse. The Big Three automakers (General Motors, Ford, and Chrysler) grow stronger.
1932	Ford introduces its V-8 engine.
1933	Cadillac introduces independent, front-wheel suspension. The first drive-in theater opens in New Jersey.
1934	Chrysler introduces its first streamlined car, the Airflow. The design proves to be too radical, and production is abandoned.
1935	The number of cars with radios exceeds the three-million mark.

1936 Cars begin to concentrate even more on styling and elegance.

1937 Chrysler surpasses Ford to become the No. 2 car maker in the country. GM owns 42 percent of the market, Chrysler owns 25 percent, Ford owns 21 percent, and all others account for 12 percent.

1938 Ford introduces the Mercury to enter the middle-class car market.

1939 World War II begins.
Two-tone and metallic coatings for cars become popular, and the demand for station wagons rises.
Over half of all new cars now have heaters.
Oldsmobile introduces its automatic transmission.
Ford's production reaches 2,700,000; Chevrolet's, 1,500,000.